I Will Be Love

Dearest Jan,

 May you come to know, love, and be inspired
by St. Therese's words in this book.
 Happy Birthday!

 Much Love,
 John and Eleanor

MAGNIFICAT would like to thank the grandchildren
of George Desvallières: Thérèse de Bayser, Bernadette Dumont,
and Gabriel Ambroselli, for allowing the reproduction of works
from their collection for the illustration of this book.

Thanks also to Claire Denis, granddaughter of Maurice Denis,
and Fabienne Stahl for their precious help.

Publisher: Romain Lizé
Editor: Claire Stacino
Graphic design: Gauthier Delauné
Iconography: Isabelle Mascaras
Proofreading: Sam Wigutow
Translation: Michael J. Miller
Production: Thierry Dubus and Sonia Romeo
Photo engraving: SNO

www.magnificat.com

THÉRÈSE OF LISIEUX

I Will Be Love

The Little Way of Love lived and revealed by Thérèse of Lisieux

Original texts selected by Benedicte Delelis
Artistic design by Pierre-Marie Dumont

MAGNIFICAT®

Paris • New York • Oxford • Madrid

TABLE OF CONTENTS

Foreword

FOR LOVE TO BE LOVED
Pierre-Marie Dumont

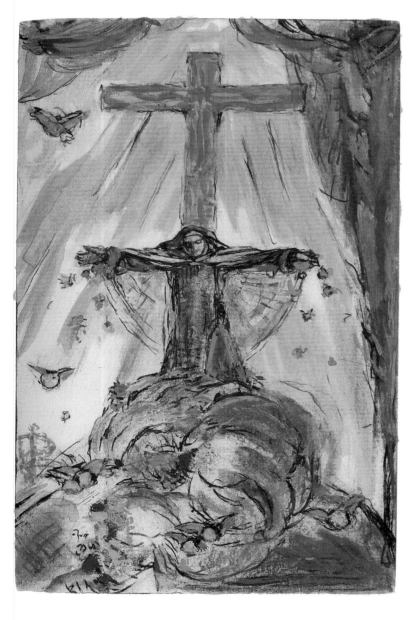

"During the Process [of beatification], when the Promoter of the Faith asked me why I wanted the beatification of Sister Thérèse of the Child Jesus, I told him that it was only to make known her *'little way.'* That is what she called her spirituality, her way of going to God. He replied: 'If you speak of a "way," the Cause will infallibly fail, as it has already happened in several similar circumstances.' 'So be it,' I replied, 'the fear of losing the Cause of Sister Thérèse cannot prevent me from emphasizing the only point that interests me: to have, in a way, the *"little way"* canonized," Thus speaks Céline,[1] in religion Sister Geneviève of the Holy Face, the most intimate sister of the little Thérèse.[2]

It is this *"little way"* that this book offers you to go through or to go through again, lived and revealed by the little Thérèse herself. Moreover, along this path, you will discover an environment, landscapes, faces, allegories that speak to the soul and the heart, far beyond what words can express. You will be able to appreciate what depth of resonance the language of the greatest artists of her time gives to the simplest words of the little Thérèse.

For those who embark on the little path of Love according to Thérèse, there is a road to travel, there are stages to reach... and to cross, crossings that little Thérèse herself sometimes calls a conversion.[3] On the way, you will share with her powerful spiritual experiences,[4] wonderful joys, but also many trials to go through, and soon the dark night that will surround her until her death. The only things that remain constant along her

little way are the spirit of spiritual childhood,[5] of total abandonment and, of course, finally, the only good solution to everything: Love.

AN ULTIMATE CONVERSION: THE COMMANDMENT OF LOVE

It is precisely with regard to Love that little Thérèse lived her ultimate "conversion," at the last stage of her life, as an accomplishment. As she entered the terminal phase of the terrible illness that would take her away a year later, she did not even have the consolation of seeing the dark night of faith, in which she was immersed, light up with the slightest glimmer.[6] And when her elder sister and godmother, Marie-Louise—in religion Sister Marie du Sacré-Coeur—asked her for her recipe for loving the good God as she loved him, Thérèse replied: "It is, in fact, spiritual riches that make one unjust, when one rests on them with complacency and believes that they are something great...."[7] This warning, in the form of a testament, is also addressed to all of us who would like so much to follow Thérèse on her little path of Love, and to be accompanied by her, until the blessed fulfillment of our lives.

From her own experience as assistant to the novice-mistress—an experience that shows that spiritual riches can divert us from the little way of Love—little Thérèse was to rediscover, so to speak, the extraordinary divinizing power of the new Commandment of Jesus. For Thérèse, loving others for the love of God has always been the privileged means of the little way, the only way to verify, in reality, that one loves God in act and in truth, and this even more so when she no longer feels the love of God. But in this final stage, the meditation on the new Commandment makes her realize that in putting into practice the Commandment of Jesus, "his own Commandment," it is no longer a question of loving others *for* the love of God, but *of* the love of God itself.[8]

THERE IS ONLY ONE LOVE

In fact, the little way of Love according to Saint Thérèse joins the way that surpasses all others, the one that Saint Paul designates in his epistle to the Corinthians (1 Cor 12:31). And Saint Paul categorically affirms that, outside of this way, all spiritual gifts are nothing (1 Cor 13:1-3). As we have seen, Thérèse goes so far as to warn that they can make us unjust. This way which, according to Saint Paul, is the only way to eternal life—the one he solemnly reveals in his "Hymn to Charity" and which little Thérèse so marvelously followed and promoted with her own genius and charisma—this way consists in the fact that by the grace of the New Commandment, our love for others is the manifestation of God's love for others, of our personal love for God, and of God's love for us personally: there is but one Love. That is why Saint John can truly say: *The love of God is this, that we keep his commandments* (1 Jn 5:3), and again: if we love one another as Jesus has loved us, *God remains in us, and his love is brought to perfection in us* (1 Jn 4:12).

There is only one Love, because *God is Love* (1 Jn 4:8). "I want to make people love LOVE," said Thérèse. Her little way proposes no other goal than to lead us to make the *Love of God reach its perfection in us.*

"WE WILL BE JUDGED ON LOVE"

When Jesus returns in glory and we beg him one last time: "O take my soul, take it, Lord," it is precisely on this true criterion of our love for God that we will be judged, and on this criterion only (Mt 25:31-46). In this sense, the spiritual master of little Thérèse, doctor of the Dark Night, Saint John of the Cross, said: "We will be judged on love." In the spirit of the little way, we must be even more precise: we will be judged on Love, by Love.

Let us not be mistaken, then: the little way of the love of God as actually walked by little Thérèse is terribly demanding. It is proposed to us as a path to be walked in our real life, in deeds and in truth and not in thought and in speech (1 Jn 3:18). It is a path desirable for its simplicity, its spirit of childhood and abandonment, but also difficult in the sense of being narrow according to the Gospel (Mt 7:13-14); a path where it is only a question of "giving everything and giving oneself"; a steep path that leads from conversion to conversion, from the love of God as we like to experience it ("spiritual riches") to the love of God as God loves us and really gives himself to be loved until Jesus returns, that is, in the putting into practice of the new Commandment. A little way that consists of loving one's own who are in the world and loving them to the end, to the point of giving one's life for them. A little way that could turn out to be a way of the cross.

1. Céline Martin, Conseils et souvenirs, Cerf/Desclée de Brouwer, 1973.

2. "She was asked by what name we should pray to her when she was in Heaven: 'You will call me little Thérèse', she replied." Céline Martin, ibid.

3. Notably on Christmas Day 1886. See page 62.

4. Thérèse herself would minimize her spiritual experiences to emphasize the simplicity of her little way: "humility, supernatural poverty, and trust in God." In this sense, her sister Céline, Sister Geneviève de la Sainte Face in religion, writes: "The Summarium recorded this answer I made about [Thérèse's] spiritual gifts: 'They were only very rare in the life of the Servant of God. For myself, I would rather she not be beatified than not give her portrait as I believe it to be accurate in conscience.'" Celine Martin, Ibid.

5. "It is the Gospel itself, it is the heart of the Gospel that she [Thérèse] rediscovered; but with what grace and freshness: 'If you do not become like children, you shall not enter the Kingdom of Heaven' (Mt 18:3)" Pius XII, Radio Message for the Consecration of the Basilica of Saint for the Consecration of the Basilica of Saint Thérèse of Lisieux, July 11, 1954.

6. In the summer of 1897, Thérèse wrote to Mother Marie de Gonzague, "When I sing of the happiness of heaven, the eternal possession of God, I feel no joy, for I sing what I want to believe." Thérèse de Lisieux par elle-même, Grasset/Desclée de Brouwer, 1997.

7. Ibid. Thérèse meditated a great deal and commented on the conclusion of the Sermon on the Mount, Mt 7:21-23: Not everyone who says to me, "Lord, Lord," will enter the kingdom of heaven, but only the one who does the will of my Father in heaven. Many will say to me on that day, "Lord, Lord, did we not prophesy in your name? Did we not drive out demons in your name? Did we not do mighty deeds in your name?" Then I will declare to them solemnly, "I never knew you. Depart from me, you evildoers."

8. See page 178 the letter of Thérèse to Mother Marie de Gonzague (Manuscript C).

Preface
"I AM NOT A SAINT"
Bénédicte Delelis

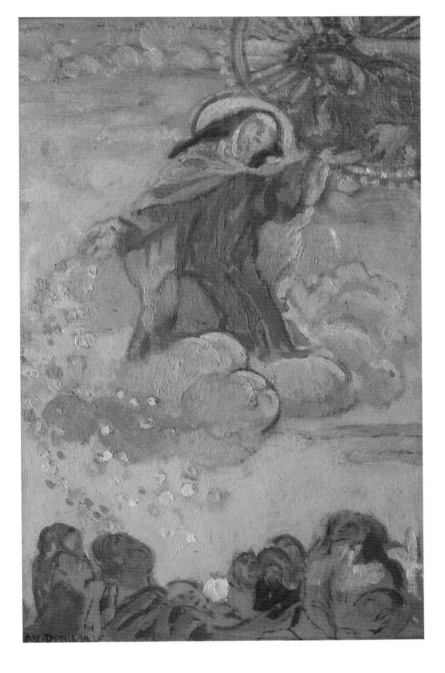

" I am not a saint," said Thérèse of Lisieux on her deathbed. "I am a very small soul whom the good Lord has filled with graces." That is why, since her death in the Carmel on September 30, 1897, the one who was at once affectionately called the little Thérèse has never ceased to inspire, to console, to protect sinners, the devout, the powerful, and the poor. Thérèse is patroness of France like Joan of Arc, patroness of the missions like Francis Xavier, Doctor of the Church like Thomas Aquinas. And yet, she knew neither Greek nor Hebrew, spent her life within four walls, and liberated neither Orleans nor Reims. Thérèse had a tenderness and sensitivity that almost broke her, a detachment from herself and an endurance of suffering that made her a soldier. When we look at her life, we discover with amazement that all her desires were fulfilled beyond her expectations, and we begin to dream: what if God did the same for us? That is why this book gathers some of her greatest texts: so that after her, with her, we may walk the path of radical humility that has only to throw itself into the arms of God and rely on him alone, hoping for everything from him, with a crazy and loving audacity.

I. Darling Thérèse

From birth to her mother's death

John Henry Twachtman, *On the Terrace*

January 2, 1873 - August 28, 1877

I must share with you an event that will probably take place at the end of the year, but which is of hardly any interest to anyone but me at the moment…. However, I would be happy over it if I knew that I could raise this little poor little person who is coming to live in our home.

I'm already thinking about the end of the year because of the child who's coming as my New Year's gift. How will I raise [it]? I have nightmares about it every night. Oh well, I have to hope that I'll come through it better than I think and that I will not have the sorrow of losing [it].

Thérèse was the last child of the Martin Family. In 1872, when her mother Zélie discovered that she was pregnant, her maternal joy was mixed with great anxieties. It was her ninth pregnancy and, by the age of forty-one, she had already had the sorrow of losing four children at an early age: two boys, both named Joseph, Hélène, who died when she was only five, and a first little Thérèse.

Thérèse was born in Alençon on January 2, 1873. Her father Louis Martin was a clockmaker and jeweler; her mother Zélie Guérin—a lacemaker. She had four sisters: Marie, Pauline, Léonie, and Céline, who was four years older than she. After being nursed by Rose Taillé in the countryside in order to strengthen her frail health, Thérèse returned to her family home, where she was cherished tenderly. Her little childish personality unfolded. She was happy, tenderhearted, ardent in her love, impetuous, and extremely determined.

My little one is not at all difficult during the day, but at night she often makes us pay dearly for her good day. Last night I held her until 11:30. I was exhausted, and I couldn't do it any more. Fortunately, afterwards she didn't do anything but sleep. This child is named Thérèse, like my last little girl. Everybody tells me that she'll be beautiful. She already laughs. I saw this for the first time on Tuesday. I thought I was mistaken, but yesterday it was impossible to doubt it any longer. She looked at me very carefully, then gave me a delightful smile.

This child is named Thérèse

From Zélie's letters

Berthe Morisot, *The Cradle*

Here, Thérèse quotes a letter from her mother Zélie to her sisters Pauline and Marie, on June 25, 1874, which ends thus: "I am very happy to see that she has so much affection for me, but it is sometimes embarrassing!"

God was pleased all through my life to surround me with *love*, and the first memories I have are stamped with smiles and the most tender caresses. But although he placed so much love near me, he also sent much *love* into my little heart, making it warm and affectionate. I loved Mama and Papa very much and showed my tenderness for them in a thousand ways, for I was very expressive.

"The little one has just placed her hand on my face and kissed me. This poor little thing doesn't want to leave me; she's continually at my side. She likes going into the garden, but when I'm not there she won't stay but cries till they bring her to me...."

And from another letter:

"Little Thérèse asked me the other day if she would go to Heaven. I told her 'Yes' if she were good. She answered: 'Yes, but if I'm not good, I'll go to hell. But I know what I will do. I will fly to you in Heaven, and what will God be able to do to take me away? You will be holding me so tightly in your arms!' I could see in her eyes that she was really convinced that God could do nothing to her if she were in her mother's arms."

Maurice Denis, *Child on the Doorstep*

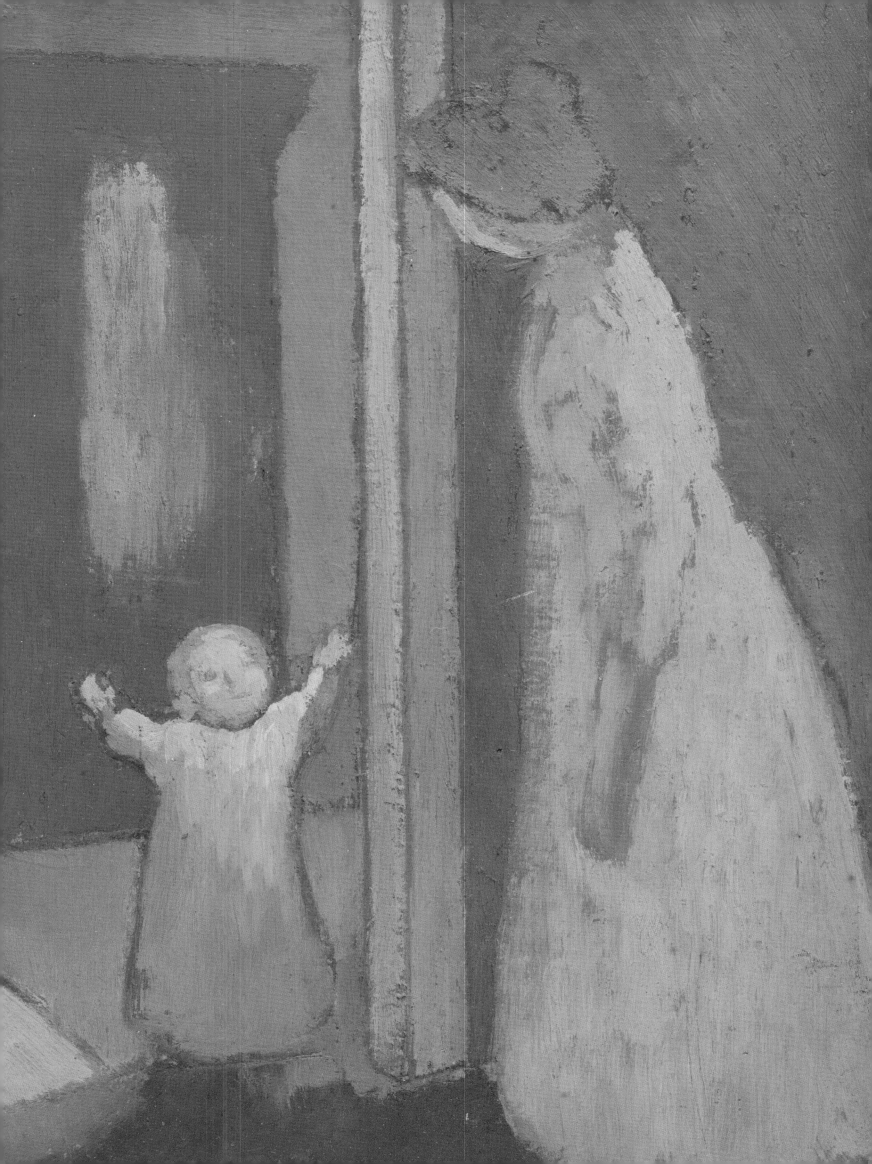

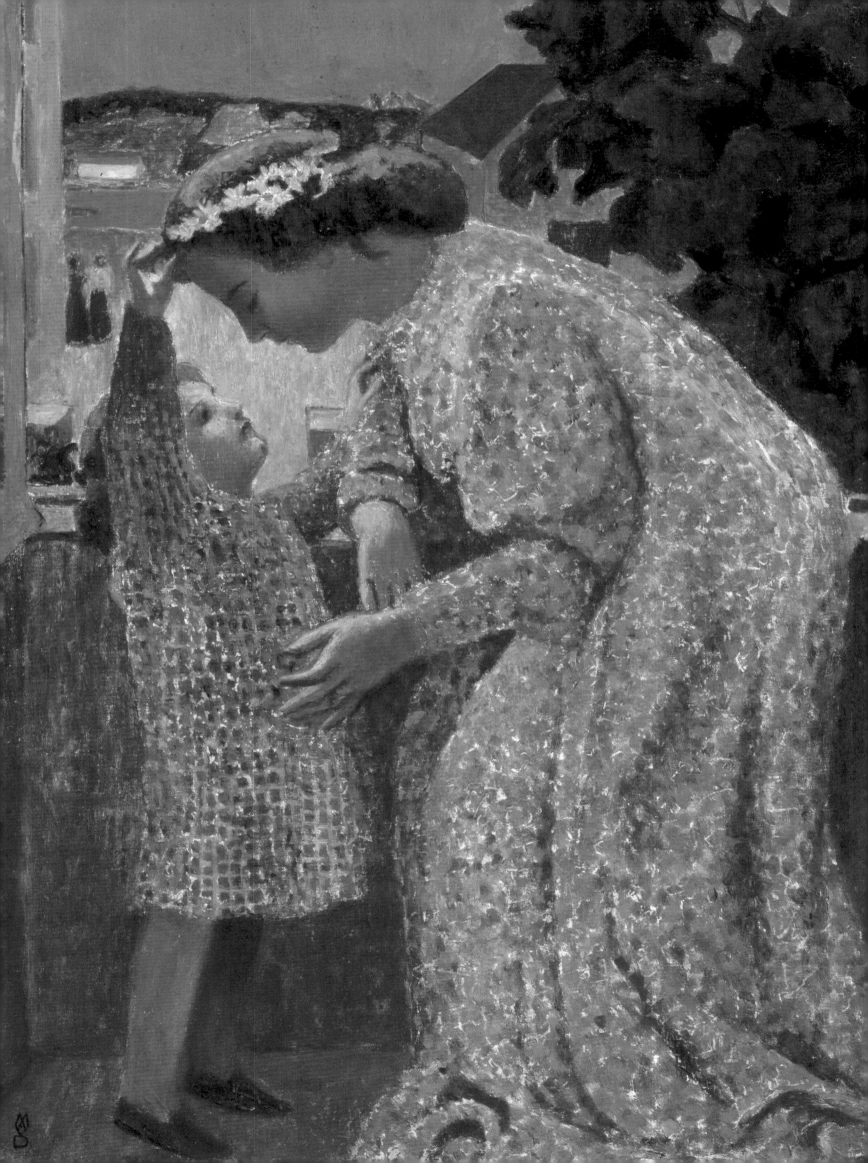

Oh! how I love the memory
Of blessèd days in infancy—.
My innocence a flower He guarded....
He surrounded me, the Lord above
With love!

Yes, I was little; nonetheless
My heart was filled with tenderness—
This love it had, it could not but express:
My promise to the King of Heav'n,
Was giv'n.

I loved Mama—her smile. Serene,
It spoke of things that were not seen:
"My joy is in Eternity. I mean
To go and see the God of Love
Above."

Maurice Denis, *The Crown*

I was very proud of my two older sisters, but the one who was my ideal from childhood was Pauline. When I was beginning to talk, Mama would ask me: "What are you thinking about?" and I would answer invariably: "Pauline!"

... I had often heard it said that surely Pauline would become a religious, and without knowing too much about what it meant I thought: "I too will be a religious." This is one of my first memories and I haven't changed my resolution since then!

... And now I have to speak about my dear Céline, the little companion of my childhood.... Here is a passage from one of Mama's letters showing how good Céline was and how I was just the opposite. "My little Céline is drawn to the practice of virtue; it's part of her nature; she is candid and has a horror of evil. As for the little imp, one doesn't know how things will go, she is so small, so thoughtless! Her intelligence is superior to Céline's, but she's less gentle and has a stubborn streak in her that is almost invincible; when she says 'no' nothing can make her give in, and one could put her in the cellar a whole day and she'd sleep there rather than say 'yes.'"

"I am obliged to correct this poor little baby who gets into frightful tantrums; when things don't go just right and according to her way of thinking (Zélie writes concerning Thérèse), she rolls on the floor in desperation like one without any hope. There are times when it gets too much for her and she literally chokes."

... You can see, dear Mother, how far I was from being a faultless little child! They weren't even able to say about me: "She's good when she's asleep" because at night I was more restless than during the day....

There was another fault I had when wide awake, which Mama doesn't mention in her letters, and this was an excessive self-love.... One day, Mama said: "Little Thérèse, if you kiss the ground I'll give you a sou." A sou was a fortune at the time...and still my pride revolted at the thought of "kissing the ground"; so standing up straight, I said to Mama: "Oh! no, little Mother, I would prefer not to have the sou!"

Restless and proud...

At the beginning of this excerpt, Thérèse quotes a letter from her mother Zélie to her sister Pauline, December 5, 1875.

Dear little Louise,

I don't know you, but I love you very much just the same. Pauline told me to write you; she is holding me on her knees because I don't know how to hold a pen. She wants me to tell you that I'm a lazy little girl, but this isn't true because I work all day long playing tricks on my poor little sisters. So I'm a little rascal who is always laughing. Adieu, little Louise. I'm sending you a big kiss.

Thérèse

Louise Magdelaine is the recipient of Thérèse's very first letter at the age of 4.

One day, Léonie, thinking she was too big to be playing any longer with dolls, came to us with a basket filled with dresses and pretty pieces for making others; her doll was resting on top. "Here, my little sisters, choose; I'm giving you all this." Céline stretched out her hand and took a little ball of wool that pleased her. After a moment's reflection, I stretched out mine saying: "*I choose all!*" and I took the basket without further ceremony. Those who witnessed the scene saw nothing wrong and even Céline herself didn't dream of complaining (besides, she had all sorts of toys, her godfather gave her lots of presents, and Louise found ways of getting her everything she desired).

This little incident of my childhood is a summary of my whole life; later on, when perfection was set before me, I understood that to become a saint one had to suffer much, seek out always the most perfect thing to do, and forget self. I understood, too, there were many degrees of perfection and each soul was free to respond to the advances of our Lord, to do little or much for him, in a word, to *choose* among the sacrifices he was asking. Then, as in the days of my childhood, I cried out: "My God, 'I choose all!' I don't want to be a saint by halves, I'm not afraid to suffer for you, I fear only one thing: to keep my own will; so take it, for 'I choose all' that you will!"

Thérèse talks about two of her sisters, when she herself is four years old. Léonie is 9 years older than Thérèse. Céline is 4 years older.

I choose all

Winter

Oh! everything truly smiled upon me on this earth: I found flowers under each of my steps and my happy disposition contributed much to making life pleasant, but a new period was about to commence for my soul. I had to pass through the crucible of trial and to suffer from my childhood in order to be offered earlier to Jesus. Just as the flowers of spring begin to grow under the snow and to expand in the first rays of the sun, so the little flower whose memories I am writing had to pass through the winter of trial.

Bertha Wegmann,
Picking Flowers

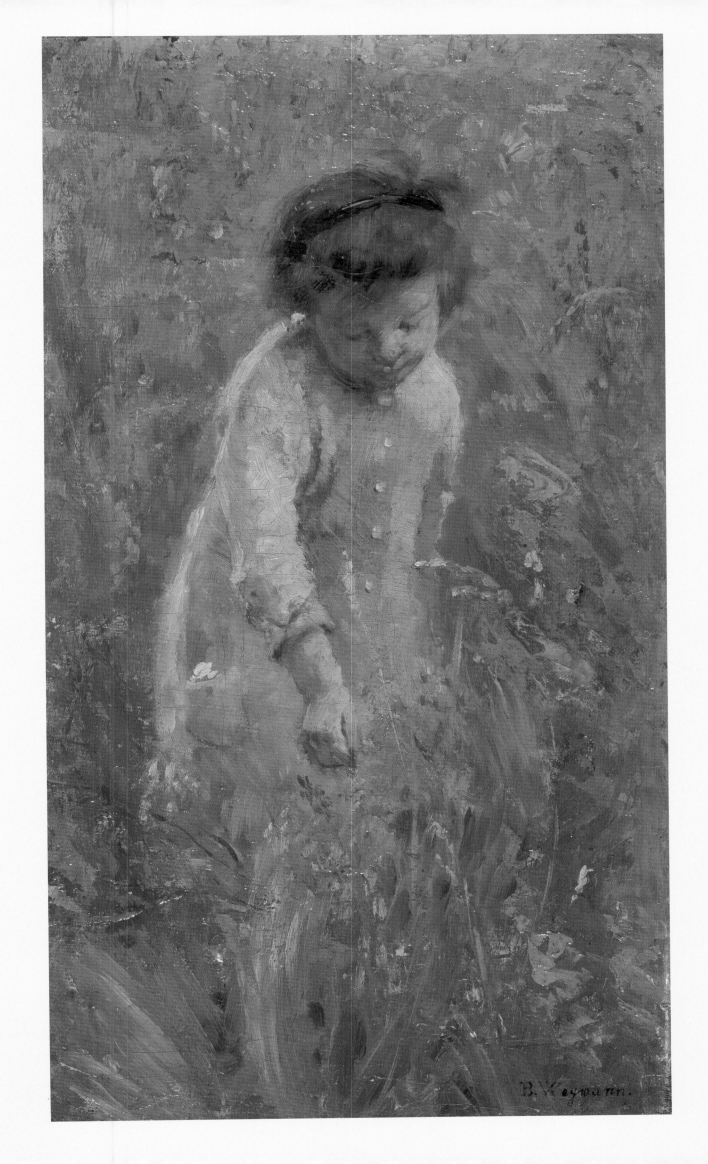

When Thérèse was four years old,
the kingdom of childhood collapsed.
Her mother, Zélie, suffered from breast
cancer, which carried her off during
the night of August 27-28, 1877.

All the details of my mother's illness are still present to me and I recall especially the last weeks she spent on earth. Céline and I were like two poor little exiles....

The touching ceremony of the last anointing is also deeply impressed on my mind. I can still see the spot where I was by Céline's side. All five of us were lined up according to age, and Papa was there too, sobbing.

The day of Mama's departure or the day after, Papa took me in his arms and said: "Come, kiss your poor little Mother for the last time." Without a word I placed my lips on her forehead. I don't recall having cried very much, neither did I speak to anyone about the feelings I experienced. I looked and listened in silence. No one had any time to pay attention to me, and I saw many things they would have hidden from me. For instance, once I was standing before the lid of the coffin, which had been placed upright in the hall. I stopped for a long time gazing at it. Though I'd never seen one before, I understood what it was. I was so little that in spite of Mama's small stature, I had to raise my head to take in its full height. It appeared *large and dismal*.

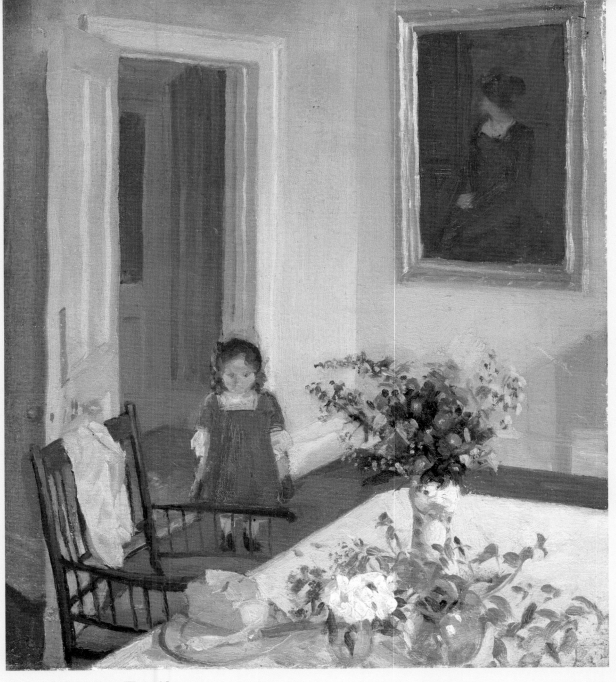

Harold Gilman, *The Absence*

The day the Church blessed the mortal remains
of our dear mother, now in heaven, God willed
to give me another mother on earth. He willed
also that I choose her freely. All five of us were gathered
together, looking at each other sadly. Louise was there
too, and, seeing Céline and me, she said: "Poor little
things, you have no mother any more!" Céline threw her
arms around Marie saying: "Well, you will be my Mama!"
Accustomed to following Céline's example, I turned
instead to you, Mother, and as though the future had
torn aside its veil, I threw myself into your arms, crying:
"Well, as for me, it's Pauline who will be my Mama!"

On August 29, 1877,
her mother, Zélie was
buried. Thérèse chose her
sister Pauline, who is
11 years older than she,
as her second mama.

Oh! I would like to sing, Mary, why I love you,
Why your sweet name thrills my heart,
And why the thought of your supreme greatness
Could not bring fear to my soul.
If I gazed on you in your sublime glory,
Surpassing the splendor of all the blessed,
I could not believe that I am your child.
O Mary, before you I would lower my eyes!...

If a child is to cherish his mother,
She has to cry with him and share his sorrows.
O my dearest Mother, on this foreign shore
How many tears you shed to draw me to you!....
In pondering your life in the holy Gospels,
I dare look at you and come near you.
It's not difficult for me to believe I'm your child,
For I see you human and suffering like me....

Giuseppe Magni, *The Virgin and the Little Children*

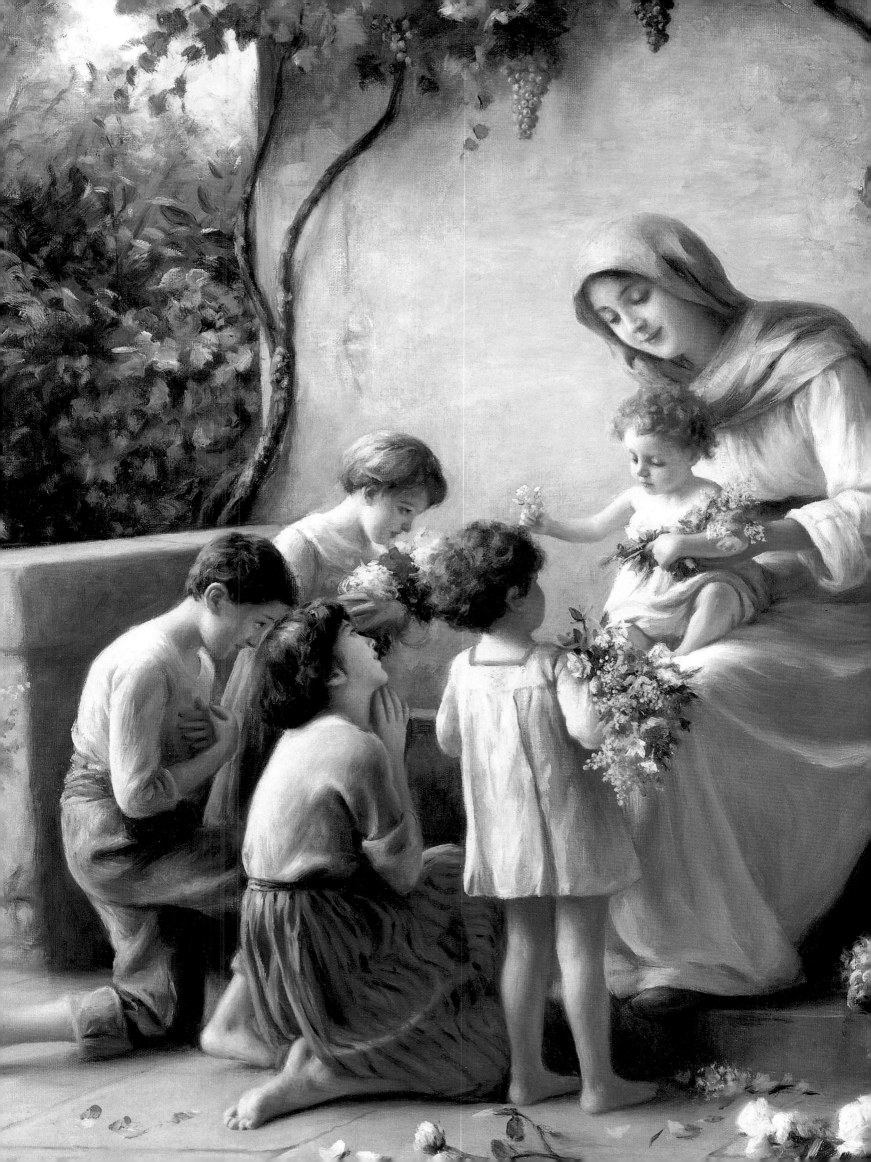

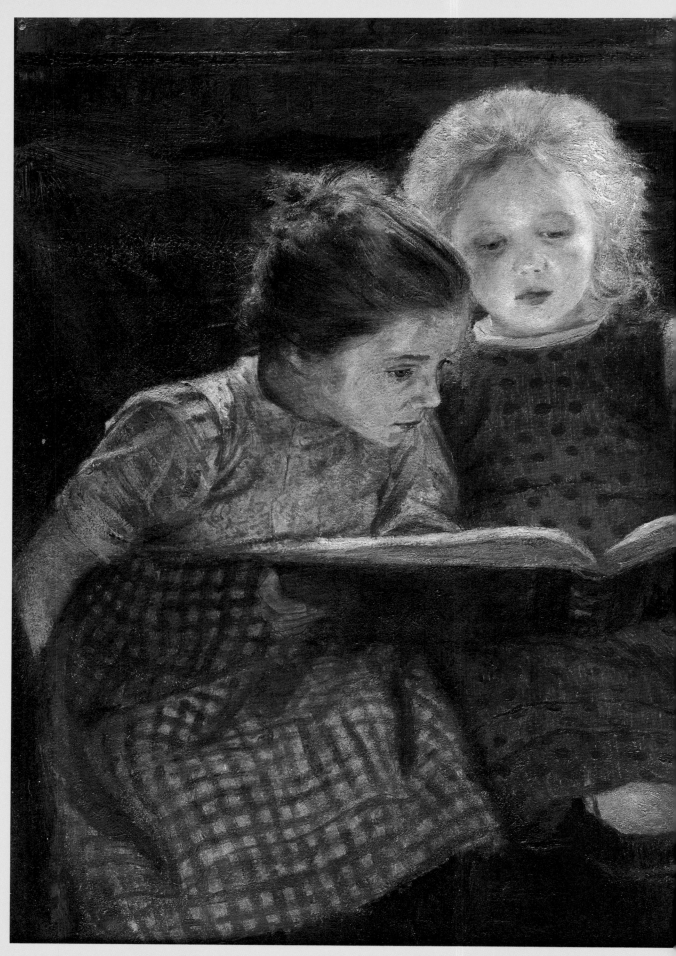

Walter Firle, *A Good Book*

II. *Thérèse dying and cured*

November 15, 1877 - May 13, 1883

The bereaved family moved from Alençon to Lisieux,
near Uncle and Aunt Guérin, to a house named
Les Buissonnets. Louis sold the family lace business,
to take care of the education of his daughters. Pauline
became the little mother of Thérèse and provided her
education together with Marie, the oldest sister.
With the death of her mama, Thérèse lost the spiritual
vitality of her infancy. She became even more sensitive.
Timid to an unhealthy degree, she could be cheerful
again only within the very restricted circle of her family.

Broken

It's from the end of this phase in my life that I entered the second period of my existence, the most painful of the three, especially since the entrance into Carmel of the one whom I chose as my second "Mama." This period extends from the age of four and a half to that of fourteen, the time when I found once again my *childhood* character, and entered more and more into the serious side of life.

I must admit, Mother, my happy disposition completely changed after Mama's death. I, once so full of life, became timid and retiring, sensitive to an excessive degree. One look was enough to reduce me to tears, and the only way I was content was to be left alone completely. I could not bear the company of strangers and found my joy only within the intimacy of the family.

And still I continued to be *surrounded* with the most delicate tenderness. Our Father's very affectionate heart seemed to be enriched now with a truly maternal love! You and Marie, Mother, were you not the most tender and selfless of mothers?

Manuscript A

As soon as my classes were over, I climbed up to the belvédère and showed my badge and my marks to Papa. How happy I was when I could say: "I got *full marks*, and it's *Pauline* who said so *first!*"... Each afternoon I took a walk with Papa. We made our visit to the Blessed Sacrament together, going to a different church each day, and it was in this way we entered the Carmelite chapel for the first time. Papa showed me the choir grille and told me there were nuns behind it. I was far from thinking at that time that nine years later I would be in their midst!

After the walk (during which Papa bought me a little present worth a few sous) we returned to the house; then I did my homework and the rest of the time I stayed in the garden with Papa, jumping around, etc., for *I didn't know how to play* with dolls.... I loved cultivating my little flowers in the garden Papa gave me. I amused myself, too, by setting up little altars in a niche in the middle of the wall. When I completed my work, I ran to Papa and dragged him over, telling him to close his eyes and not open them till I told him. He did all I asked him to do and allowed himself to be led in front of my little garden, then I'd cry out: "Papa, open your eyes!" He would open them and then go into an ecstasy to please me, admiring what I believed was really a masterpiece! I would never come to an end if I really wanted to portray a thousand little actions like this which crowd into my memory. How could I possibly express the tenderness which *"Papa"* showered upon his little queen?

Papa

Thérèse was almost 7 years old
at the time of her first confession,
end of 1879 or beginning of 1880.

What a sweet memory for me!

Oh! dear Mother, with what care you prepared me for my first confession, telling me it was not to a man but to God I was about to tell my sins; I was very much convinced of this truth. I made my confession in a great spirit of faith, even asking you if I had to tell Father Ducellier I loved him with all my heart as it was to God in person I was speaking.

Well instructed in all I had to say and do, I entered the confessional and knelt down. On opening the grating Father Ducellier saw no one. I was so little my head was below the arm-rest. He told me to stand up. Obeying instantly, I stood and faced him directly in order to see him perfectly, and I made my confession like a *big girl* and received his blessing with *great devotion*, for you had told me that at the moment he gave me absolution the *tears of Jesus* were going to purify my soul.... Coming out of the confessional I was so happy and lighthearted that I had never felt so much joy in my soul. Since then I've gone to confession on all the great feasts, and it was truly a feast for me each time.

The feasts!... If the big feasts were rare, each week brought one that was very dear to my heart, namely Sunday! What a day Sunday was for me! It was God's feast day, and feast of rest.... [At Mass] I listened attentively to the sermons, which I understood very poorly. The first I *did understand and which touched me deeply* was a sermon on the Passion preached by Father Ducellier and since then I've understood all the others. When the preacher spoke about Saint Teresa, Papa leaned over and whispered: "Listen carefully, little Queen, he's talking about your Patroness." I did listen carefully, but I looked more frequently at Papa than at the preacher, for his handsome face said so much to me!...

I return once more to my Sundays. This joyous day, passing all too quickly, had its tinge of *melancholy*. I remember how my happiness was unmixed until Compline. During this prayer, I would begin thinking that the day of *rest* was coming to an end, that the morrow would bring with it the necessity of beginning life over again; we would have to go back to work, to learning lessons, etc., and my heart felt the exile of this earth. I longed for the everlasting repose of heaven, that never-ending *Sunday* of the *Fatherland*!

Thérèse recalls a sermon
by Father Ducellier in April 1878.
She was then 5 years old.

I sighed

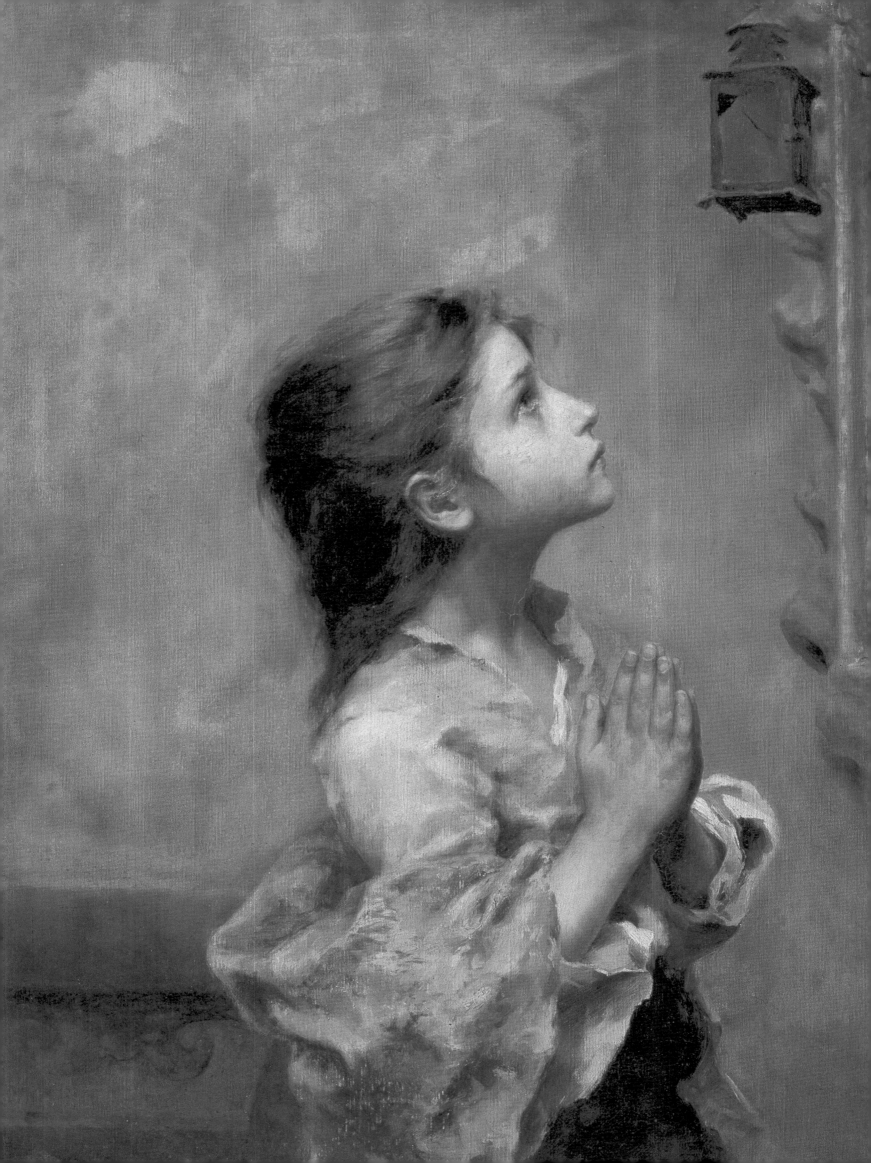

Glorious Guardian of my soul,
You who shine in God's beautiful Heaven
As a sweet and pure flame
Near the Eternal's throne,
You come down to earth for me,
And enlightening me with your splendor,
Fair Angel, you become my Brother,
My Friend, my Consoler!...

Knowing my great weakness,
You lead me by the hand,
And I see you tenderly
Remove the stone from my path.
Your sweet voice is always inviting me
To look only at Heaven.
The more you see me humble and little,
The more your face is radiant.

My Guardian Angel

Roberto Ferruzzi, *Praying Girl*

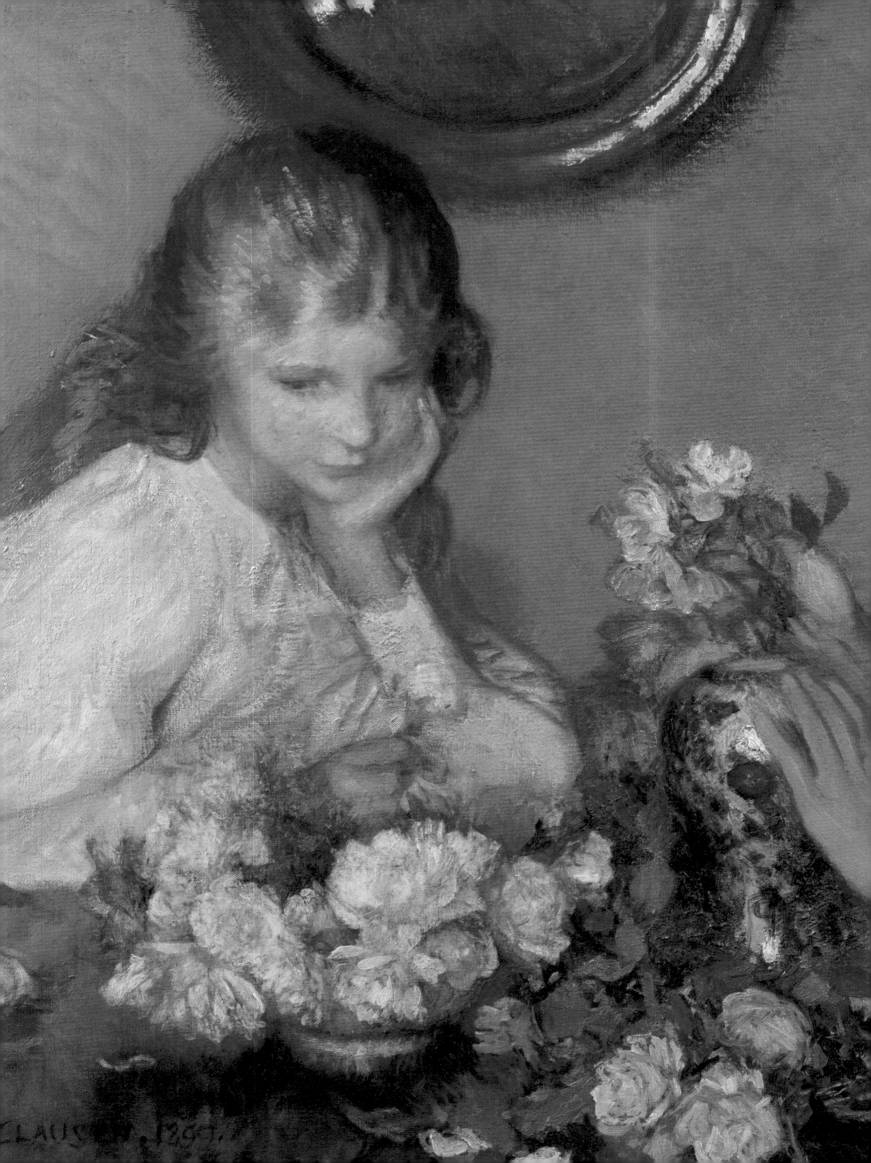

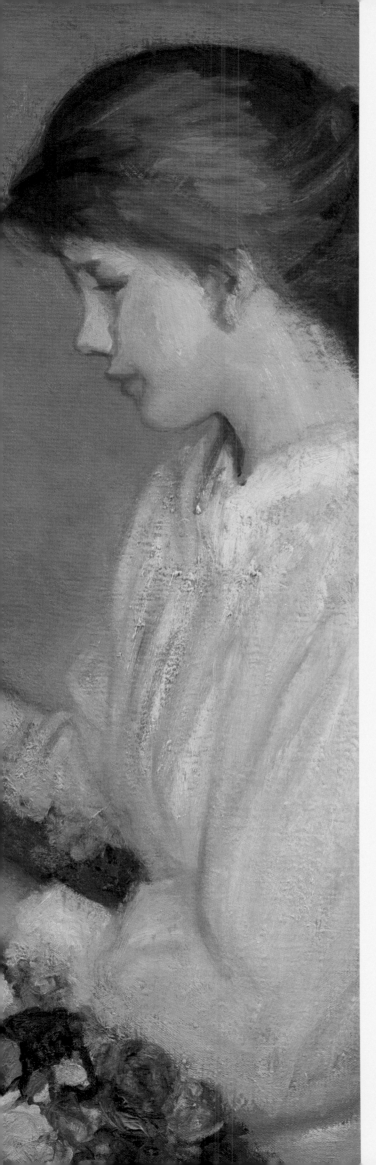

George Clausen,
Two Girls Arranging Roses

The Thimble

It was Pauline, too, who received all my intimate confidences and cleared up all my doubts. Once I was surprised that God didn't give equal glory to all the elect in heaven, and I was afraid all would not be perfectly happy. Then Pauline told me to fetch Papa's large tumbler and set it alongside my thimble and filled both to the brim with water. She asked me which one was fuller. I told her each was as full as the other and that it was impossible to put in more water than they could contain. My dear mother helped me understand that in heaven God will grant his elect as much glory as they can take, the last having nothing to envy in the first.

When reading the accounts of the patriotic deeds of French heroines, especially the Venerable JOAN OF ARC, I had a great desire to imitate them; and it seemed I felt within me the same burning zeal with which they were animated, the same heavenly inspiration. Then I received a grace which I have always looked upon as one of the greatest in my life because at that age I wasn't receiving the lights I'm now receiving when I am flooded with them. I considered that I was born for glory and when I searched out the means of attaining it, God... made me understand my own glory would not be evident to the eyes of mortals, that it would consist in becoming a great saint! This desire could certainly appear daring if one were to consider how weak and imperfect I was, and how, after seven years in the religious life, I still am weak and imperfect. I always feel, however, the same bold confidence of becoming a great saint because I don't count on my merits since I have none, but I trust in him who is Virtue and Holiness. God alone, content with my weak efforts, will raise me to himself and make me a saint, clothing me in his infinite merits. I didn't think then that one had to suffer very much to reach sanctity, but God was not long in showing me this was so and in sending me the trials I have already mentioned.

Maurice Denis,
The Communion of Joan of Arc

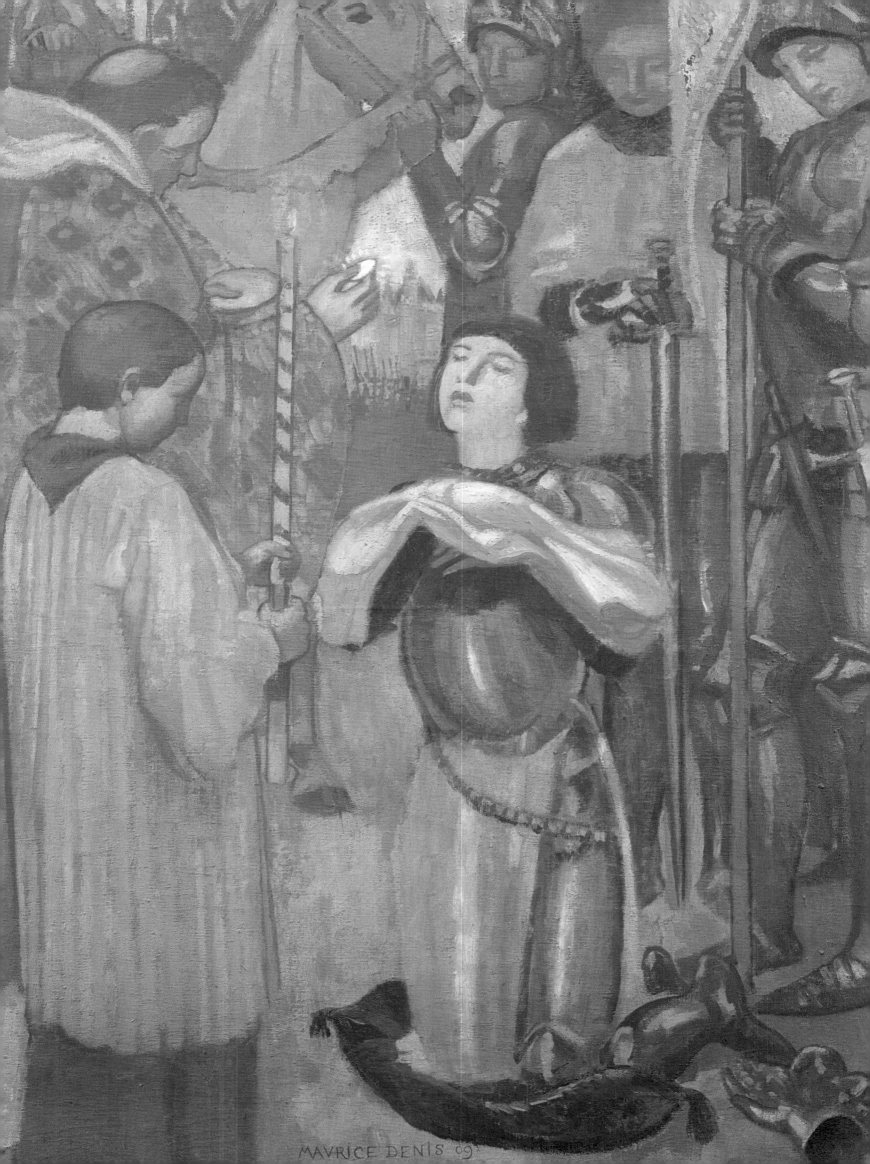

MAVRICE DENIS 09

I was eight and a half when Léonie left boarding
school and I replaced her at the Abbey. I have
often heard it said that the time spent at school is
the best and happiest of one's life. It wasn't this way
for me. The five years I spent in school were the sad-
dest in my life, and if I hadn't had Céline with me, I
couldn't have remained there and would have become
sick in a month. The poor little flower had become
accustomed to burying her fragile roots in a chosen
soil made purposely for her. It seemed hard for her to
see herself among flowers of all kinds with roots fre-
quently indelicate; and she had to find in this *com-
mon soil* the food necessary for her sustenance!...

As I was timid and sensitive by nature, I didn't
know how to defend myself and was content to cry
without saying a word and without complaining *even
to you* about what I was suffering. I didn't have enough
virtue, however, to rise above these miseries of life, so
my poor little heart suffered very much. Each evening
I was back at home, fortunately, and then my heart
expanded. I would jump up on Papa's lap, telling him
about the marks they were giving me, and his kiss
made me forget my troubles.

Now I must speak of the sorrowful trial that broke little Thérèse's heart when Jesus took away her dear Mama, her tenderly loved *Pauline!*...

How [little Thérèse] suffered when she heard her dear Pauline speaking one day to Marie about her coming entrance into Carmel. I didn't know what Carmel was, but I understood that Pauline was going to leave me to enter a convent.... Ah! how can I express the anguish of my heart! In one instant, I understood what life was; until then, I had never seen it so sad; but it appeared to me in all its reality, and I saw it was nothing but a continual suffering and separation....

I shall always remember, dear Mother, with what tenderness you consoled me. Then you explained the life of Carmel to me and it seemed so beautiful!... I felt that Carmel was the *desert* where God wanted me to go also to hide myself. I felt this with so much force that there wasn't the least doubt in my heart; it was not the dream of a child led astray but the *certitude* of a divine call; I wanted to go to Carmel not for *Pauline's* sake but for *Jesus* alone.

One day, Thérèse overheard that her sister Pauline, her second mother, was going to enter the Carmel. Her heart was broken. This second separation, which was finalized on October 2, 1882, was so traumatic for the child's soul that she fell sick during the following winter, at the age of 10.

Continual sufferings and separations

My loss of Pauline

I still see the spot where I received *Pauline's* last kiss; and then Aunt brought us to Mass, while Papa went to Mount Carmel to offer his *first sacrifice*. The whole family was in tears so that people who saw us coming into the church looked at us in surprise. But it was all the same to me and it didn't prevent me from crying. I believed that if everything crumbled around me, I would have paid no attention whatsoever. I looked up at the beautiful blue skies and was astonished the Sun was shining with such brightness when my soul was flooded with sadness!...

Every Thursday we went as a family to Carmel and I, accustomed to talk heart-to-heart with Pauline, obtained with great trouble two or three minutes at the end of the visit. It is understood, of course, that I spent them in crying and left with a broken heart.... I said in the depths of my heart: "Pauline is lost to me!" It is surprising to see how much my mind developed in the midst of suffering; it developed to such a degree that it wasn't long before I became sick.

Around Easter of 1883 an acute
health crisis developed. On April 6
the family managed to bring
Thérèse to the Carmel for Pauline's
clothing ceremony, but she had
a relapse shortly afterward. They
thought that Thérèse was dying.
She rambled, no longer recognized
her sisters, no longer ate. Her father,
Louis, had everyone make a novena
to Our Lady of Victory.

The inexplicable sickness

Toward the end of the year, I began to have a constant head-ache. It didn't cause me much suffering. I was able to pursue my studies and nobody was worried about me. This lasted until Easter, 1883. Papa had gone to Paris with Marie and Léonie, and Aunt had taken me and Céline with her into her home. One evening Uncle took me for a walk and spoke about Mama and about past memories with a kindness that touched me profoundly and made me cry.... That night...when I was undressing, I was seized with a strange trembling. Believing I was cold, Aunt covered me with blankets and surrounded me with hot water bottles. But nothing was able to stop my shaking, which lasted almost all night. Uncle...went to get Doctor Notta the next day, and he judged...that I had a very serious illness and one which had never before attacked a child as young as I. Everybody was puzzled....

I said and did things that were not in my mind. I appeared to be almost always delirious, saying things that had no meaning. And still I am *sure* that I *was not deprived of the use of my reason for one single instant*. I often appeared to be in a faint, not making the slightest movement....

My greatest consolation when I was sick was to receive a letter from Pauline. I read and reread it until I knew it by heart.

Finding no help on earth, poor little Thérèse had also turned toward the Mother of heaven, and prayed with all her heart that she take pity on her. All of a sudden the Blessed Virgin appeared *beautiful* to me, so *beautiful* that never had I seen anything so attractive; her face was suffused with an ineffable benevolence and tenderness, but what penetrated to the very depths of my soul was the "ravishing smile of the Blessed Virgin." At that instant, all my pain disappeared, and two large tears glistened on my eyelashes, and flowed down my cheeks silently, but they were tears of unmixed joy. Ah! I thought, the Blessed Virgin smiled at me, how happy I am....

Alas!...my happiness was going to disappear and change into bitterness. The memory of the ineffable grace I had received was a real *spiritual trial* for me for the next four years.... Marie, having heard the simple and sincere recital of "my grace," asked me for permission to tell it at Carmel, and I could not say no. On my first visit to this dear Carmel...I was questioned about the grace I had received. They asked me if the Blessed Virgin was carrying the Child Jesus, or if there was much light, etc. All these questions troubled me and caused me much pain, and I was able to say only one thing: "The Blessed Virgin had appeared *very beautiful, and I had seen her smile at me.*" It was her *countenance alone* that had struck me, and seeing that the Carmelites had imagined something else entirely...I thought I *had lied....* *Humiliation* becoming my lot, I was unable to look upon myself without a feeling of *profound horror.* Ah! what I suffered I shall not be able to say except in heaven!

On Pentecost Sunday, 1883, May 13, Thérèse was convinced that she has been healed by Mary's smile. She was 10 years old. Her happiness lasted only a short time. Very soon afterward, it was darkened by what she would call the "sickness of scruples." Thérèse feared that she had invented her sickness and her miraculous cure.

Mary's smile

Odilon Redon, *Virgin*

Come smile at me again

You love us, Mary, as Jesus loves us,

And for us you accept being separated from Him.

To love is to give everything. It's to give oneself.

You wanted to prove this by remaining our support.

The Savior knew your immense tenderness.

He knew the secrets of your maternal heart.

Refuge of sinners, He leaves us to you

When He leaves the Cross to wait for us in Heaven.

Soon I'll hear that sweet harmony.

Soon I'll go to beautiful Heaven to see you.

You who came to smile at me in the morning of my life,

Come smile at me again... Mother.... It's evening now!...

I no longer fear the splendor of your supreme glory.

With you I've suffered, and now I want

To sing on your lap, Mary, why I love you,

And to go on saying that I am your child!

Amédée Buffet,
Thérèse and the Smiling Virgin

III. Thérèse shattered and recovered

*From Mary's smile
to the grace of Christmas*

George Clausen,
The Daisy Wreath

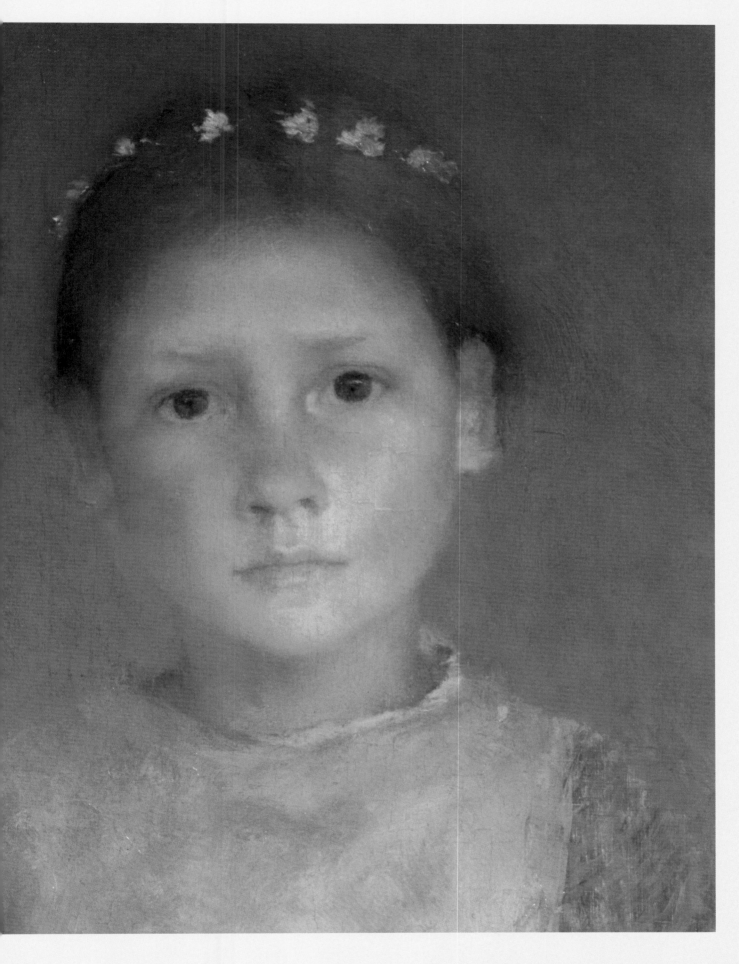

May 1883 - Christmas 1886

Learning to fight

After the Virgin Mary's smile, life went on again. Marie, the older sister of Thérèse and her godmother, continued the little girl's education.

Pauline was replaced by Marie. I sat on her lap and listened *eagerly* to everything she said to me. It seemed to me her *large* and *generous* heart passed into my own. Just as famous warriors taught their children the art of war, so Marie spoke to me about life's *struggles* and of the palm given to the victors. She spoke also about the eternal riches that one can so easily amass each day, and what a misfortune it was to pass by without so much as stretching forth one's hand to take them. She explained the way of becoming *holy* through fidelity in little things; furthermore, she gave me a little leaflet called "Renunciation" and I meditated on this with delight.

George Desvallières,
"More than a kiss, a making-one"

Ah! how sweet was that first kiss of Jesus!

It was a kiss of love; *I felt that I was loved*, and I said: "I love you, and I give myself to you forever!" There were no demands made, no struggles, no sacrifices; for a long time now Jesus and poor little Thérèse *looked at* and understood each other. That day, it was no longer simply a look, it was a *fusion*; they were no longer two, Thérèse had vanished as a drop of water is lost in the immensity of the ocean. Jesus alone remained; he was the Master, the King. Had not Thérèse asked him to take away her *liberty*, for her *liberty* frightened her? She felt so feeble and fragile that she wanted to be united forever to the divine Strength!

The high point of this time in the life of Thérèse was her joyful First Holy Communion on May 8, 1884. The child prepared for it by making many little sacrifices: flowers for the Child Jesus.

It was a kiss of love

Manuscript A

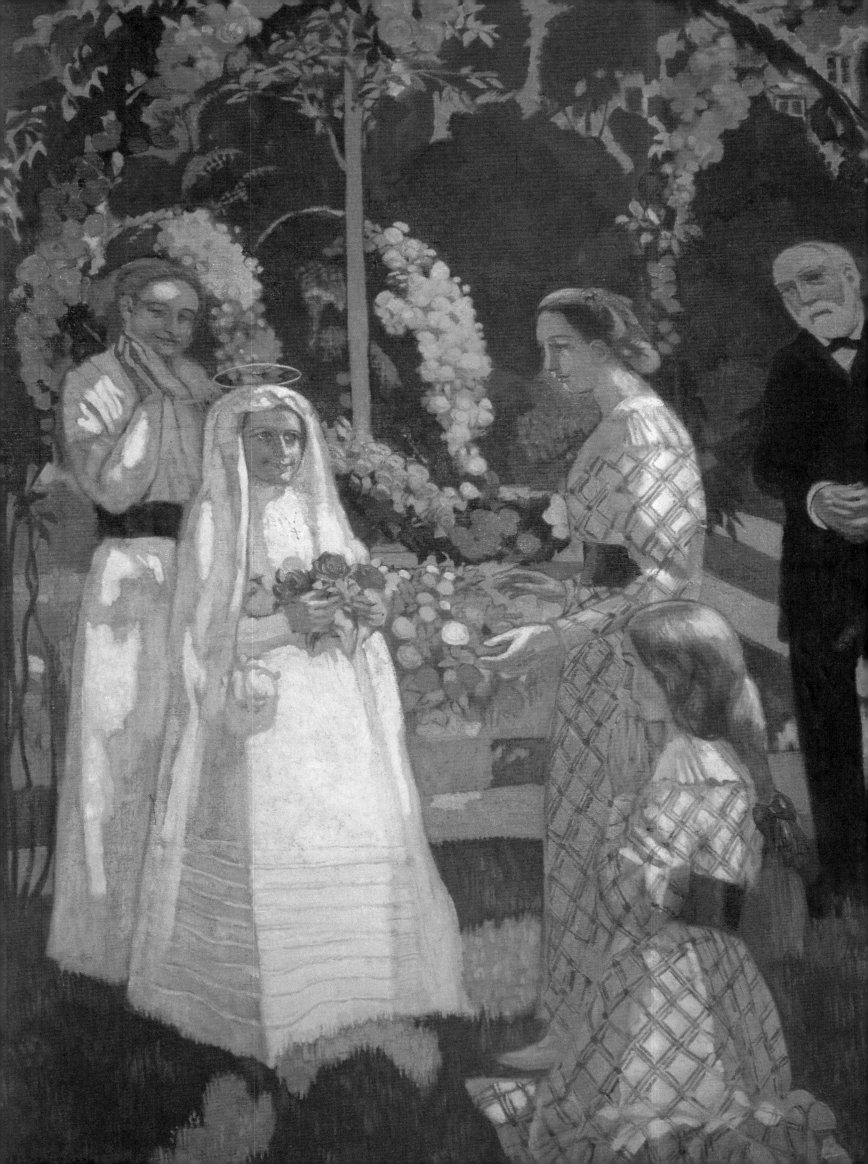

Her joy was too great, too deep for her to contain, and tears of consolation soon flowed, to the great consternation of her companions. They asked one another: "Why was she crying? Was there something bothering her?" — "No, it was because her mother was not there or her sister whom she loves so much, her sister the Carmelite." They did not understand that all the joy of Heaven having entered my heart, this exiled heart was unable to bear it without shedding tears. Oh! no, the absence of Mama didn't cause me any sorrow on the day of my First Communion. Wasn't Heaven itself in my soul, and hadn't Mama taken her place there a long time ago? Thus in receiving Jesus' visit, I received also Mama's. She blessed me and rejoiced at my happiness. I was not crying because of Pauline's absence. I would have been happy to see her by my side, but for a long time I had accepted my sacrifice of her. On that day, joy alone filled my heart and I united myself to her who gave herself irrevocably to him who gave himself so lovingly to me!

Heaven in my soul

Manuscript A

Maurice Denis, *First Communion of Saint Thérèse of Lisieux*

Little Key, I envy you

Little Key, oh, I envy you!
For each day you can open
The prison of the Eucharist
Where the God of Love resides.
But, O what a sweet miracle!
By just an effort of my faith
I can also open the tabernacle
To hide near the Divine King...

Holy Paten, I envy you.
Upon you Jesus comes to rest.
Oh! may his infinite grandeur
Deign to humble itself even to me...
Fulfilling my hope, Jesus
Does not wait until the evening of my life.
He comes within me; by his presence
I am a living Monstrance!...

My Desires near Jesus Hidden in His Prison of Love

Maurice Dhomme, *Tabernacle
of the church of Saint Louis in Vincennes*

A short time after my First Communion, I entered upon another retreat for my Confirmation. I was prepared with great care to receive the visit of the Holy Spirit, and I did not understand why greater attention was not paid to the reception of this sacrament of *Love*....

Ah! how happy my soul was! Like the Apostles, I awaited the Holy Spirit's visit with great happiness in my soul. I rejoiced at the thought of soon being a perfect Christian and especially at that of having eternally on my forehead the mysterious cross the bishop marks when conferring this sacrament. Finally the happy moment arrived, and I did not experience an impetuous wind at the moment of the Holy Spirit's descent but rather this *light breeze* which the prophet Elias heard on Mount Horeb. On that day, I received the strength to *suffer*, for soon afterward the martyrdom of my soul was about to commence.

Shortly after her First Communion, Thérèse was confirmed, on June 14, 1884, by Bishop Hugonin of Bayeux. Her sister, Léonie, was her Confirmation sponsor.

The visit of the Holy Spirit

Maurice Dhomme, *Chair of the church of Saint Louis in Vincennes*

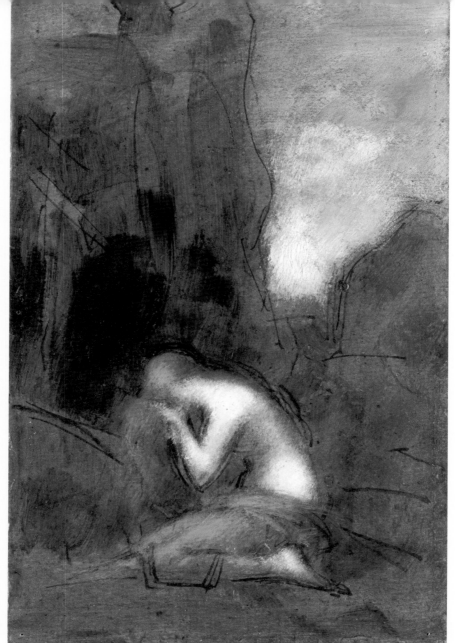

Jean-Jacques Henner,
Weeping Magdalene

Ah! I feel it! Jesus knew I was too feeble to be exposed to temptation; perhaps I would have allowed myself to be burned entirely by the *misleading light* had I seen it shining in my eyes.... I know that without him, I could have fallen as low as Saint Mary Magdalene, and the profound words of our Lord to Simon resound with a great sweetness in my soul. I know that "he to whom less is forgiven LOVES less," but I also know that Jesus has *forgiven me more than Saint Mary Magdalene* since he forgave me *in advance* by preventing me from falling.... I am...the object of the foreseeing love of a Father who has not sent his Word to save the *just*, but *sinners*. He wants me to *love* him because he has *forgiven* me not much but *ALL*. He has not expected me to *love him much* like Mary Magdalene, but he has willed that I KNOW how he has loved me with a love of unspeakable foresight in order that now I may love him unto *folly*!

R eally tell them, Mother, that if I had committed all possible crimes, I would always have the same confidence; I feel that this whole multitude of offenses would be like a drop of water thrown into a fiery furnace.

A drop of water in a fiery furnace

Yellow Notebook, July 11, 1897

The year following my First Communion passed almost entirely without any interior trials for my soul. It was during my retreat for the second Communion that I was assailed by the terrible sickness of scruples. One would have to pass through this martyrdom to understand it well, and for me to express what I suffered for *a year and a half* would be impossible. All my most simple thoughts and actions became the cause of trouble for me, and I had relief only when I told them to Marie. This cost me dearly, for I believed I was obliged to tell her the absurd thoughts I had even about her. As soon as I laid down my burden, I experienced peace for an instant; but this peace passed away like a lightning flash, and soon my martyrdom began over again.

Scruples

The year 1885–1886 was darkened by the scruples that assailed Thérèse concerning everything. Every evening Marie listened to the "confession" of her little sister, who imagined that she had committed serious sins and was upset about everything. In July 1886, Thérèse went to Trouville to visit her Aunt Guérin, but there she felt so disoriented that she had to be sent back home, to Les Buissonnets. Thérèse's unhealthy sensitivity caused her much suffering.

On October 15, 1886, it was the turn of Marie, another sister of Thérèse, to enter the Carmel. Thérèse was thirteen years old. This departure was another severe trial for her. Although Marie could not replace Pauline in her heart, she had become indispensable to her. After losing all intimacy with Pauline, now she had to give up Marie, too! Thérèse turned once more to Heaven for help. It was the intercession of her four little brothers and sisters in heaven that granted her the grace of peace of heart. She was completely delivered from her sickly scruples at the feet of Our Lady of Victory in November 1887, at the age of 14.

When Marie entered Carmel, I was still very scrupulous. No longer able to confide in her I turned toward heaven. I addressed myself to the four angels who had preceded me there, for I thought that these innocent souls, having never known troubles or fear, would have pity on their poor little sister who was suffering on earth. I spoke to them with the simplicity of a child, pointing out that being the youngest of the family, I was always the most loved, the most covered with my sisters' tender cares, that if they had remained on earth, they too would have given me proofs of their affection. Their departure for heaven did not appear to me as a reason for forgetting me; on the contrary, finding themselves in a position to draw from the divine treasures, they had to take peace for me from these treasures and thus show me that in heaven they still knew how to love! The answer was not long in coming, for soon peace came to inundate my soul with its delightful waves, and I knew then that if I was loved on earth, I was also loved in heaven. Since that moment, my devotion for my little brothers and sisters has grown and I love to hold dialogues with them frequently, to speak with them about the sadness of our exile, about my desire to join them soon in the Fatherland!

Maurice Denis, *Paradise*

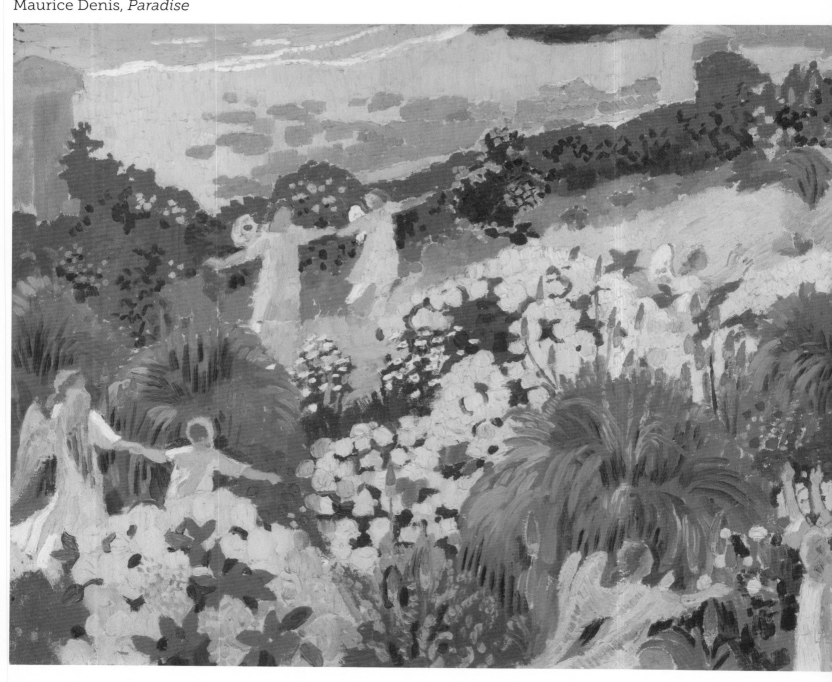

Happy little children, with what tenderness
　　The King of Heaven
Once blessed you and covered your joyous heads
　　With caresses!
You were the symbol of all Innocent Children,
　　And in you I glimpse
Blessings the King of kings gives you beyond all measure
　　In Heaven.

You have contemplated the immense riches
　　Of Paradise
Before having known our bitter sadness,
　　Dear little Lilies.
O fragrant Buds! Harvested just at dawn
　　By the Lord,
Love's sweet Sun knew how to make you blossom:
　　It was his Heart!...

It's you the Lord gives me as a model,
　　Holy Innocents.
I want to be your faithful likeness here below,
　　Little Children.
Ah! deign to obtain for me the virtues of childhood.
　　Your candor,
Your perfect surrender, your lovely innocence
　　Charm my heart.

The Christmas miracle

Thérèse's healing—"my conversion," as she put it
to her sister Céline—took place on Christmas night
1886. She felt that in an instant and mysteriously
the Almighty gave her back the strength of soul
that she had lost when her mother died. Thérèse is as
if resurrected. Love penetrates her heart and makes
it burn with a special devotion for Christ, thirsting
for souls, and for poor sinners who will be lost.

I was really unbearable because of my extreme touchiness; if I happened to cause anyone I loved some little trouble, even unwittingly, instead of forgetting about it and not *crying*, which made matters worse, I *cried* like a Magdalene and then when I began to cheer up, I'd begin *to cry again for having cried*. All arguments were useless; I was quite unable to correct this terrible fault. I really don't know how I could entertain the thought of entering Carmel when I was still in the *swaddling clothes of a child*! God would have to work a little miracle to make me *grow up* in an instant, and this miracle he performed on that unforgettable Christmas day. On that luminous night which sheds such light on the delights of the Holy Trinity, Jesus, the gentle, *little* Child of only one hour, changed the *night* of my soul into rays of light. On that night when he made himself subject to *weakness* and suffering for love of me, he made me *strong* and courageous, arming me with his weapons. Since that night I have never been defeated in any combat, but rather walked from victory to victory, beginning, so to speak, "to run as a giant"!

Maurice Denis,
Nativity at Fourqueux

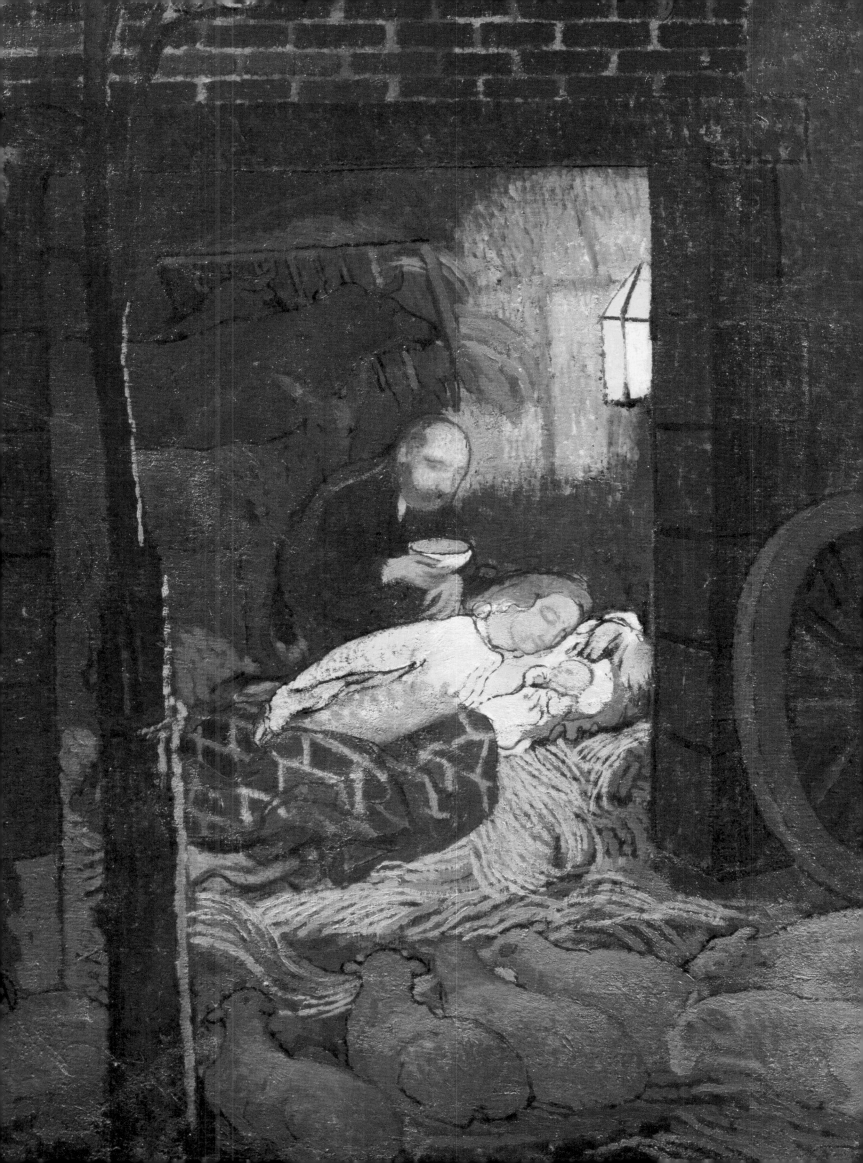

Strength in weakness

It was December 25, 1886, that I received the grace of leaving my childhood—in a word, the grace of my complete conversion. We had come back from Midnight Mass, where I had the happiness of receiving the *strong* and *powerful* God. Upon arriving at Les Buissonnets, I used to love to take my shoes from the chimney corner and examine the presents in them; this old custom had given us so much joy in our youth that Céline wanted to continue treating me as a baby since I was the youngest in the family. Papa had always loved to see my happiness and listen to my cries of delight as I drew each surprise from the *magic shoes*, and my dear King's gaiety increased my own happiness very much. However, Jesus desired to show me that I was to give up the defects of my childhood and so he withdrew its innocent pleasures. He permitted Papa, tired out after the Midnight Mass, to experience annoyance when seeing my shoes at the fireplace, and that he speak those words which pierced my heart: "Well, fortunately, this will be the last year!" I was going upstairs, at the time, to remove my hat, and Céline, knowing how sensitive I was and seeing the tears already glistening in my eyes, wanted to cry too, for she loved me very much and understood my grief. She said, "Oh, Thérèse, don't go downstairs; it would cause you too much grief to look at your slippers right now!" But Thérèse was no longer the same; Jesus had changed her heart! Forcing back my tears, I descended the stairs rapidly; controlling the poundings of my heart, I took my slippers and placed them in front of Papa, and withdrew all the objects *joyfully*. I had the happy appearance of a Queen.... Thérèse had discovered once again the strength of soul which she had lost at the age of four and a half, and she was to preserve it forever!

Love penetrated my heart

O n that *night of light* began the third period of my life, the most beautiful and the most filled with graces from heaven. The work I had been unable to do in ten years was done by Jesus in one instant, contenting himself with my *good will* which was never lacking.... He made me a fisher of souls. I experienced a great desire to work for the conversion of sinners, a desire I hadn't felt so intensely before. I felt *charity* enter into my soul, and the need to forget myself and to please others; since then I've been happy!...

"I thirst!"

One Sunday, looking at a picture of our Lord on the cross, I was struck by the blood flowing from one of the divine hands. I felt a great pang of sorrow when thinking this blood was falling to the ground without anyone's hastening to gather it up. I was resolved to remain in spirit at the foot of the cross and to receive the divine dew. I understood I was then to pour it out upon souls.... The cry of Jesus on the cross sounded continually in my heart: *"I thirst!"* These words ignited within me an unknown and very living fire.... I wanted to give my Beloved to drink and I felt myself consumed with a *thirst* for souls.... As yet, it was not the souls of priests that attracted me, but those of *great sinners*; I burned with the desire to snatch them from the eternal flames.

I heard talk of a great criminal just condemned to death for some horrible crimes; everything pointed to the fact that he would die impenitent. I wanted at all costs to prevent him from falling into hell, and to attain my purpose I employed every means imaginable. Feeling that of myself I could do nothing, I offered to God all the infinite merits of our Lord and the treasures of the Church, and finally I begged Céline to have a Mass offered for my intentions.... I felt in the depths of my heart certain that our desires would be granted, but to obtain courage to pray for sinners I told God I was sure he would pardon the poor, unfortunate Pranzini; that I'd believe this even if he went to his death *without any signs of repentance* or *without having gone to confession*. I was absolutely confident in the mercy of Jesus. But I was begging him for a *"sign"* of repentance only for my own simple consolation.

My prayer was answered to the letter! In spite of Papa's prohibition of our reading papers, I didn't think I was disobeying when reading the passages pertaining to Pranzini. The day after his execution I found the newspaper *La Croix*. I opened it quickly and what did I see?... Pranzini had not gone to confession. He had mounted the scaffold and was preparing to place his head in the formidable opening, when suddenly, seized by an inspiration, he turned, took hold of the *crucifix* the priest was holding out to him and *kissed the sacred wounds three times*!... After this unique grace my desire to save souls grows each day, and I seemed to hear Jesus say to me what he said to the Samaritan woman: "Give me to drink!"

Henri Pranzini, found guilty of a triple crime, was executed on August 31, 1887.

A great criminal

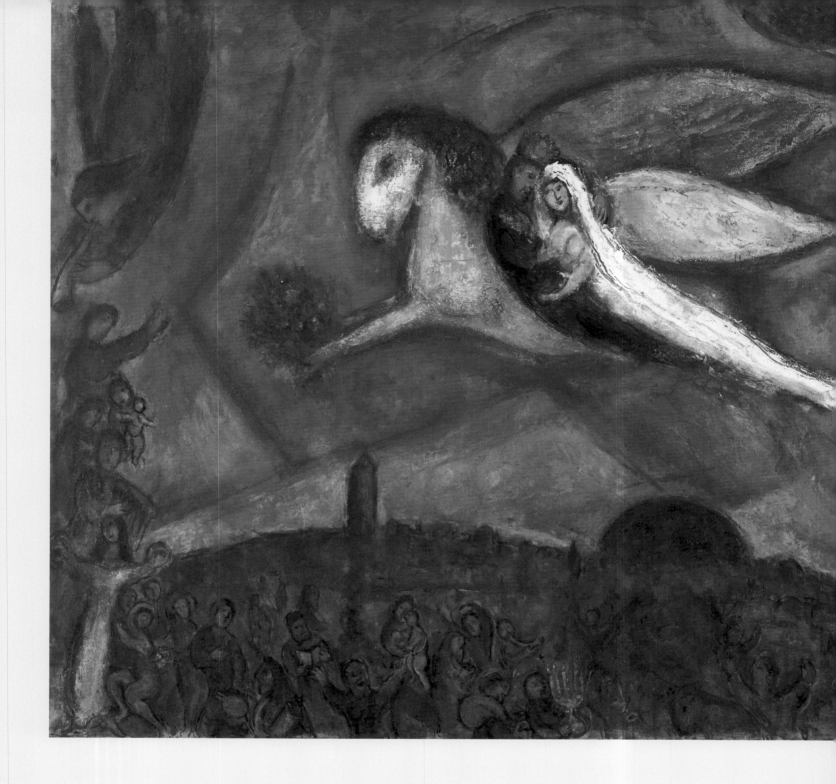

Lord, you chose me from my earliest childhood,
And I can call myself the work of your love...
O my God! in my gratitude I would like—
Oh! I would like to be able to pay you in return!...
Jesus my Beloved, what is this privilege?
What have I, poor little nothing, done for you?
And I see myself placed in the royal procession
Of the virgins in your court, lovable and divine King!

Marc Chagall,
The Song of Songs IV

Alas, I am nothing but weakness itself.

You know that, O my God! I have no virtues...

But you also know, the only friend I love,

That the one who has charmed me is you, my sweet Jesus!...

When in my young heart was enkindled that flame

Called love, you came to claim it....

And you alone, O Jesus! could satisfy a soul

That needed to love even to the infinite.

I am the work of your love

For Sister Marie of the Trinity

IV. Thérèse, determined

From the grace of Christmas to her entrance into the Carmel

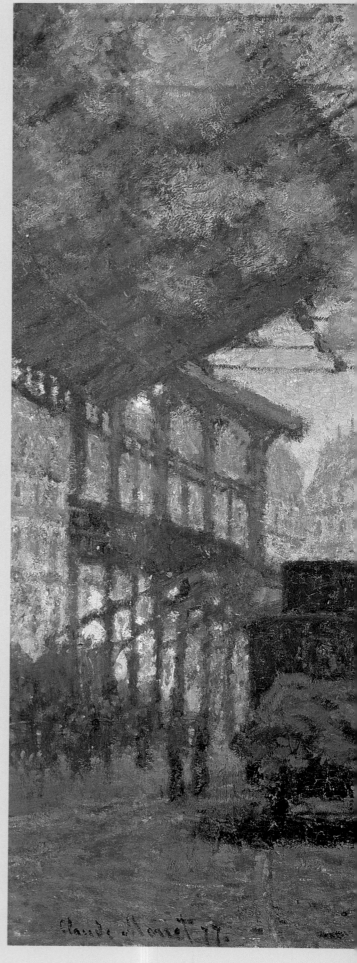

Claude Monet,
Arrival of a Train from Normandy

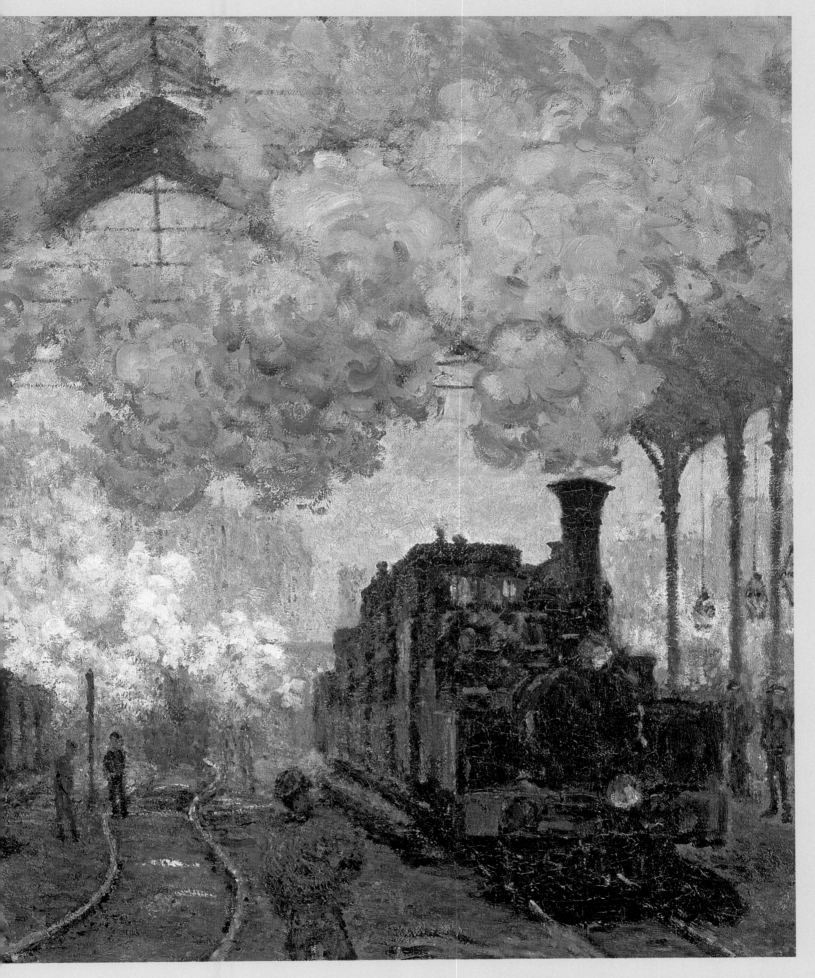

Christmas 1886 - April 9, 1888

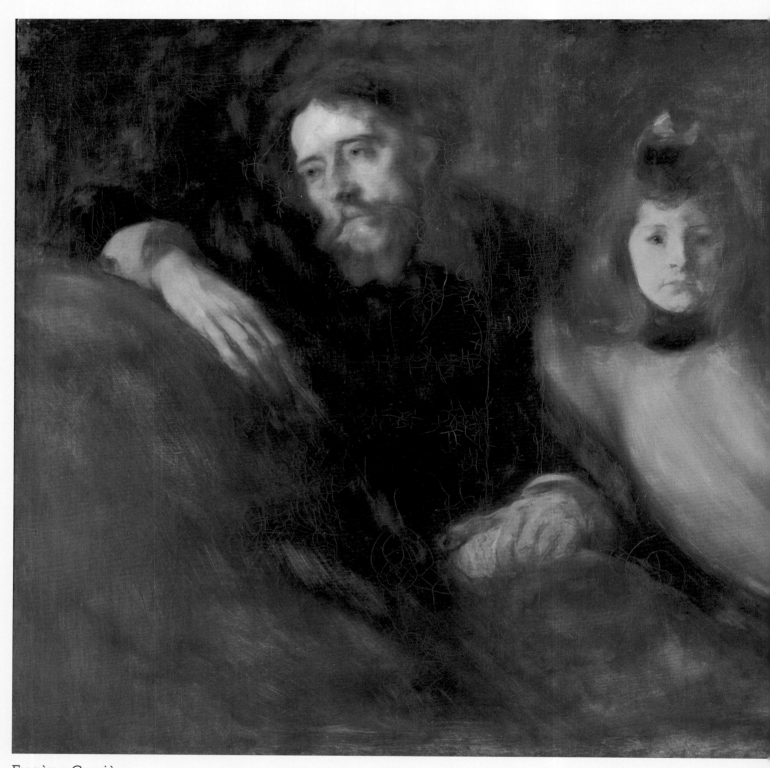

Eugène Carrière,
A Father and His Daughter

I chose the feast of *Pentecost* as the day to break the news, all day long begging the apostles to pray for me, to inspire me with the right words. Shouldn't they help the timid child who was chosen by God to be the apostle of apostles through her prayers and sacrifices in Carmel? I found the opportunity to speak to my dear little father only in the afternoon after Vespers. He was seated by the well, contemplating the marvels of nature with his hands joined.... Papa's handsome face had a heavenly expression about it, giving me the feeling that peace flooded his heart. Without saying a word, I sat down by his side, my eyes already wet with tears. He gazed at me tenderly, and taking my head he placed it on his heart, saying: "What's the matter, my little Queen? Tell me." Then, rising as though to hide his own emotion, he walked while still holding my head on his heart. Through my tears, I confided my desire to enter Carmel and soon his tears mingled with mine. He didn't say one word to turn me from my vocation, simply contenting himself with the statement that I was still very young to make such a serious decision. I defended myself so well that, with Papa's simple and direct character, he was soon convinced my desire was God's will, and in his deep faith he cried out that God was giving him a great honor in asking his children from him.

Breaking the news to Papa

Ever since Pauline (Thérèse's sister) announced that she would enter the Carmel, Thérèse had heard in her soul God's call to become a Carmelite. This call kept resounding in the heart of the little girl, who had become a young lady of fourteen years. On Pentecost Sunday, May 29, 1887, this desire to consecrate herself to God was so urgent that Thérèse went to consult Louis, her father and dear King. She told him that she wished to join the Carmelites at the age of fifteen. Thérèse obtained her father's consent without difficulty.

Manuscript A

I told you of my joy at seeing that my trials were all over. What was my surprise and sadness when you told me that the Superior was not giving his consent to my entrance until I was twenty-one. No one had thought of this opposition, and it was the most insurmountable of all. Without giving up hope, however, I went myself with Papa and Céline to pay him a visit, trying to change his mind by showing I really had a Carmelite vocation. He received us coldly; my *incomparable* little father joined his insistence to mine but in vain. Nothing would change the Superior's attitude. He told me there wasn't any danger in staying at home, I could lead a Carmelite life there, and if I didn't take the discipline all was not lost, etc., etc. He ended by saying he was only the *Bishop's delegate*, and if the latter wished me to enter Carmel, he himself would have nothing to say. I left the rectory in tears, and fortunately my umbrella was able to hide them as the rain was coming down in torrents. Papa was at a loss as to how to console me. He promised to accompany me to Bayeux the moment I expressed my desire to go there since I was *determined to do all within my power*, even saying I would go to the *Holy Father* if the bishop did not want to allow me to enter at fifteen.

In October 1887, Thérèse dared to speak about her wish to her Uncle Guérin, subrogated guardian of his niece. His first reaction was negative. But two weeks later, convinced by the persuasion of Pauline, who had become Sister Agnes of Jesus, he consented. However, the Superior of the Carmel, Canon Delatroëtte, categorically said no. The chaplain of the Carmel, Father Youf, then suggested having recourse to Bishop Hugonin of Bayeux.

I grew in love

Thérèse and her father went to the Bishop of
Bayeux on October 31; her hair was put up in a
bun to make her look older. His Excellency was
welcoming but made no decision. He suggested
that Thérèse and Louis make a pilgrimage
to Rome. The Vicar General, Monsignor
Révérony, who attended the interview, wrote
that they had never seen anything like it:
"a father as eager to give his child to the Good
Lord as that child was to offer herself!".

Many things happened before my trip to
Bayeux; exteriorly my life appeared to
be as usual. I studied, taking lessons in
drawing from Céline, and my clever teacher recog-
nized in me an aptitude for her art. Above all, I was
growing in love for God; I felt within my heart cer-
tain aspirations unknown until then, and at times I
had veritable transports of love. One evening, not
knowing how to tell Jesus that I loved him and how
much I desired that he be *loved* and glorified every-
where, I was thinking he would never receive a sin-
gle act of love from hell; then I said to God that to
please him I would consent to see myself plunged
into hell so that he would be loved eternally in that
place of blasphemy. I realized this could not give
him glory since he desires only our happiness, but
when we love, we experience the need of saying a
thousand foolish things.

The second experience I had (during my journey to Rome) relates to priests. Having never lived close to them, I was not able to understand the principal aim of the Reform of Carmel. To pray for sinners attracted me, but to pray for the souls of priests, whom I believed to be as pure as crystal, seemed puzzling to me!

I understood my *vocation* in Italy and that's not going too far in search of such useful knowledge.

I lived in the company of many *saintly priests* for a month and I learned that, though their dignity raises them above the angels, they are nevertheless weak and fragile men. If *holy priests*, whom Jesus in his Gospel calls the "salt of the earth," show in their conduct their extreme need for prayers, what is to be said of those who are tepid? Didn't Jesus say too: "If the salt loses its savor, wherewith will it be salted?"

How beautiful is the vocation, O Mother, which has as its aim the *preservation of the salt* destined for souls! This is Carmel's vocation, since the sole purpose of our prayers and sacrifices is to be the *apostle of the apostles*. We are to pray for them while they are preaching to souls through their words and especially their example. I must stop here, for were I to continue I would never come to an end!

In November-December 1887, Thérèse, Céline, and their father went on a pilgrimage to Rome with the vicar general, Monsignor Révérony. While in Paris, on November 4, they visited the church of Our Lady of Victories to thank her for her intercession and to ask her to watch over Thérèse's vocation. At the feet of the statue, Thérèse felt an emotion as strong as that of her First Communion: "The Blessed Virgin made me feel that it was really she who had smiled on me and cured me." From then on, she was definitively delivered from her sickly scruples.

As she continued her journey to Rome, Thérèse had two new experiences. With many French aristocrats making the pilgrimage at the same time, she discovered that titles are only "window dressing," and that only the quality of the soul of the person counts. Thérèse also met many priests and got to know them better. This led her to a strong desire to pray and to offer sacrifices for them. She continued to hope but abandoned herself to God's will.

Maurice Denis, *St. Peter's in Rome, Good Friday Evening*

One of my sweetest memories was the one that filled me with delight when I saw the Colosseum. I was finally gazing upon that arena where so many martyrs had shed their blood for Jesus. I was already preparing to kneel down and kiss the soil they had made holy, but what a disappointment! The place was nothing but a heap of ruins, and the pilgrims were expected to be satisfied with simply looking at these. A barrier prevented them from entering the ruins. No one would be tempted to do so. But was it possible to come all the way to Rome and not go down into the Colosseum? For me it was impossible! I no longer heard the guide's explanations. One thought raced through my mind: get down into the arena! Seeing a workman pass by carrying a stepladder, I was on the verge of asking his advice, and it was good I didn't as he would have considered me a fool.... I cried to Céline: "Come quick! We can get through!" We crossed the barrier where there was an opening, the fallen masonry hardly reaching up to the barrier, and we were climbing down over the ruins that rumbled under our feet.

Papa stared at us, surprised at our boldness. He was calling us back, but the two fugitives no longer heard anything. Just as warriors experience an increase in courage in the presence of danger, so our joy increased proportionately to the trouble we met with in attaining the object of our desire.... My heart was beating hard when my lips touched the dust stained with the blood of the first Christians. I asked for the grace of being a martyr for Jesus and felt that my prayer was answered!

Maurice Denis, *The Colosseum*

The little ball

Letter dated November 20, 1887, to Sister Agnes of Jesus

In this letter, Thérèse recounts her visit to the pope. The pilgrims passed in front of the pope and kissed his foot.

My dear little Pauline,

God is making me pass through real trials before having me enter Carmel. I am going to tell you how my visit with the pope went. Oh! Pauline, if you could only have read my heart, you would have seen there a great confidence. I believe I did what God wanted me to do, and now there remains nothing for me to do but to pray....

The pope was seated on a large chair, very high.... You can imagine how my heart was beating when seeing my turn come, but I did not want to return to my place without having spoken to the pope. I said what you were telling me in your letter but not all, for Monsieur Révérony did not give me time. He said immediately: "Most Holy Father, this is a child who wants to enter Carmel at fifteen, but the superiors are considering the matter at this moment." (The good pope is so old that one would say he is dead; I would never have pictured him like this....) I would have liked to be able to explain my business, but there was no way. The Holy Father said simply: "If God wills it, you will enter." Then they made me pass into another room. Oh! Pauline...I was crushed. I felt I was abandoned, and, then, I am so far, so far.... However, God cannot give me trials that are above my strength. He has given me the courage to bear this trial. Oh! it is very great.... But, Pauline, I am the Child Jesus' little ball; if he wishes to break his toy, he is free. Yes, I will all that he wills....

Thérésita

My heart was broken when going to Midnight Mass; I was counting so much on assisting at it behind Carmel's grilles! This trial was very great for my faith, but the One whose heart watches even when he sleeps made me understand that to those whose faith is like that of a *mustard seed* he grants *miracles* and moves mountains in order to strengthen this faith which is still *small*; but for his *intimate friends*, for his *Mother*, he works no miracles *before having tried their faith*. Did he not allow Lazarus to die even after Martha and Mary told him he was sick? At the wedding of Cana when the Blessed Virgin asked Jesus to come to the help of the head of the house, didn't he answer her that his hour had not yet come? But after the trial what a reward! The water was changed into wine… Lazarus was raised from the dead! Thus Jesus acted toward his little Thérèse: after having tried her *for a long time*, he granted all the desires of her heart.

Still nothing

The next Christmas, Thérèse hoped with all her heart to receive approval for her entrance into the Carmel, on Christmas Day, from the Child Jesus whose name she wished to bear in religion. But at Christmas—still nothing. As the month of January 1888 dawned, the much-awaited permission arrived.

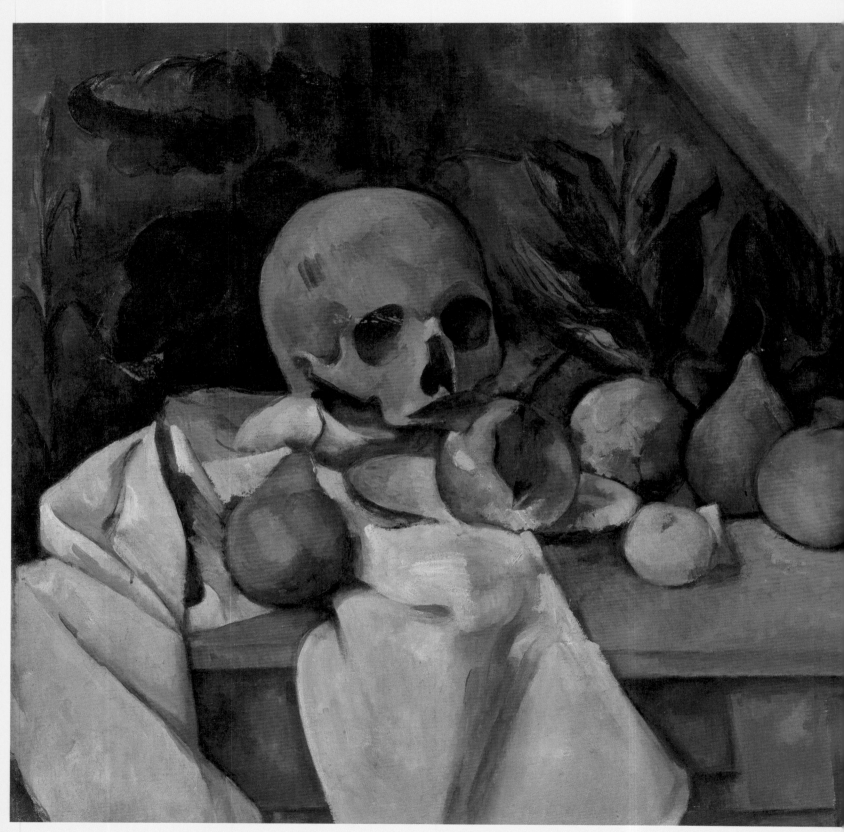

Paul Cézanne, *Still Life with Skull*

How did those *three months* pass, those months so rich in graces for me? At first the thought came into my mind not to lead a life as well regulated as had been my custom, but soon I understood the value of the time I was being offered. I made a resolution to give myself up more than ever to a *serious* and *mortified* life. When I say mortified, this is not to give the impression that I performed acts of penance. Alas, *I never made any*. Far from resembling beautiful souls who practiced every kind of mortification from their childhood, I had no attraction for this. Undoubtedly this stemmed from my cowardliness, for I could have, like Céline, found a thousand ways of making myself suffer. Instead of this I allowed myself to be wrapped in cotton wool and fattened up like a little bird that needs no penance. My mortifications consisted in breaking my will, always so ready to impose itself on others, in holding back a reply, in rendering little services without any recognition, in not leaning my back against a support when seated, etc., etc. It was through the practice of these *nothings* that I prepared myself to become the fiancée of Jesus, and I cannot express how much this waiting left me with sweet memories. Three months passed by very quickly, and then the moment so ardently desired finally arrived.

Permission from the bishop arrived on December 28, the Feast of the Holy Innocents, but Mother Marie de Gonzague, then Prioress of the Carmel, decided that the girl would not enter until after Lent— the final test of patience and abandonment for Thérèse.

Break my will

The great day

Louis Martin accompanied his Thérèse to the Carmel on Monday, April 9, 1888, when the community was celebrating the Annunciation. Here are the words with which he announced the event the following day: "My dear friends, Thérèse, my little Queen, entered Carmel yesterday!... God alone could demand such a sacrifice.... Don't sympathize with me, for my heart is overflowing with joy."

On the morning of the great day, casting a last look upon Les Buissonnets, that beautiful cradle of my childhood which I was never to see again, I leaned on my dear King's arm to climb Mount Carmel. As on the evening before, the whole family was reunited to hear Holy Mass and receive Communion. As soon as Jesus descended into the hearts of my relatives, I heard nothing around me but sobs. I was the only one who didn't shed any tears, but my heart was beating *so violently* it seemed impossible to walk when they signaled for me to come to the enclosure door. I advanced, however, as King myself whether I was going to die because of the beating of my heart! Ah! what a moment that was! One would have to experience it to know what it is.

My emotion was not noticed exteriorly. After embracing all the members of the family, I knelt down before my matchless father for his blessing, and to give it to me he placed *himself on his knees* and blessed me, tears flowing down his cheeks.

I have found it

Virgin Mary, in spite of my weakness,
On the evening of this beautiful day I want to sing
A canticle of gratitude
And my hope of being God's for ever.
Ah! for such a long time, so far from the holy ark,
My poor heart longed for Carmel.
I have found it, now no more fear.
Here I am tasting the first-fruits of Heaven!

For the Clothing of Marie-Agnes of the Holy Face

87

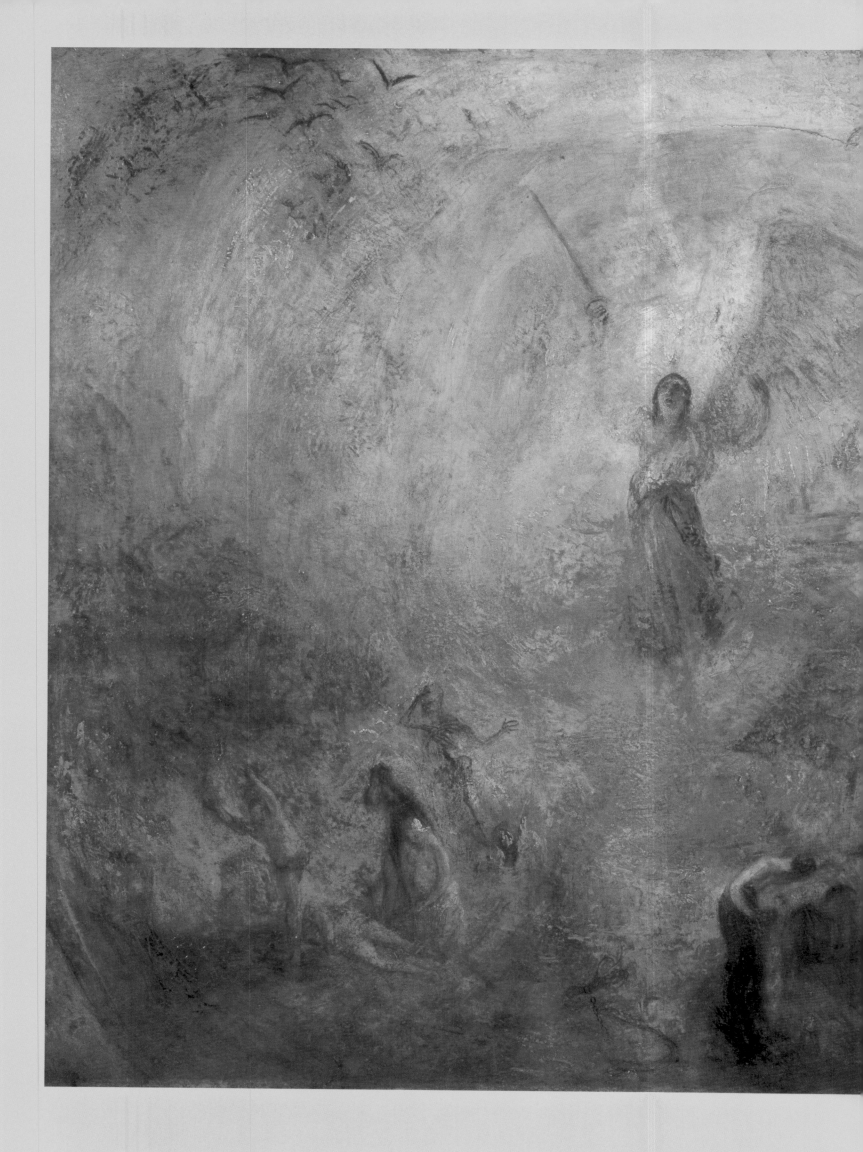

From the postulancy,
* to the day of clothing*
and receiving the veil

April 9 1888-
September 24 1890

Joseph Mallord William Turner,
The Angel Standing in the Sun

V. Thérèse, soldier: the underground passage

Thérèse entered Carmel
on April 9, 1889. She came
to save souls and to pray for priests,
and she found the life of Carmel
to be just what she had expected.
In her cell: a straw mattress on
a board, rudimentary furniture.
No water, electricity or heating.
In the winter, it was bitterly cold,
and in the summer very hot.
The Carmel of Lisieux is very small.
It had twenty-six sisters.
The prioress was Mother Marie
de Gonzague; the mistress of novices,
Sister Marie des Anges. In the novitiate,
Thérèse joined Sister Agnes of Jesus
(Pauline) and Sister Marie of the Sacred
Heart (Marie). The Martin sisters were
now three in the community.
The young postulant is asked
to work in the laundry room.

I was led, as are all postulants, to the choir immediately after my entrance into the cloister.... Ah! I was fully recompensed for all my trials. With what deep joy I repeated those words: "I am here for ever and ever!"

This happiness was not passing. It didn't take its flight with "the illusions of the first days." *Illusions, God gave me the grace not to have A SINGLE ONE* when entering Carmel. I found the religious life to be exactly as I had imagined it, no sacrifice astonished me and yet, as you know, dear Mother, my first steps met with more thorns than roses! Yes, suffering opened wide its arms to me and I threw myself into them with love. I had declared at the feet of Jesus-Victim, in the examination preceding my Profession, what I had come to Carmel for: "I came to save souls and especially to pray for priests." When one wishes to attain a goal, one must use the means; Jesus made me understand that it was through suffering that he wanted to give me souls.... This was my way for five years; exteriorly nothing revealed my suffering, which was all the more painful since I alone was aware of it. Ah! what a surprise we shall have at the end of the world when we shall read the story of souls! There will be those who will be surprised when they see the way through which my soul was guided!

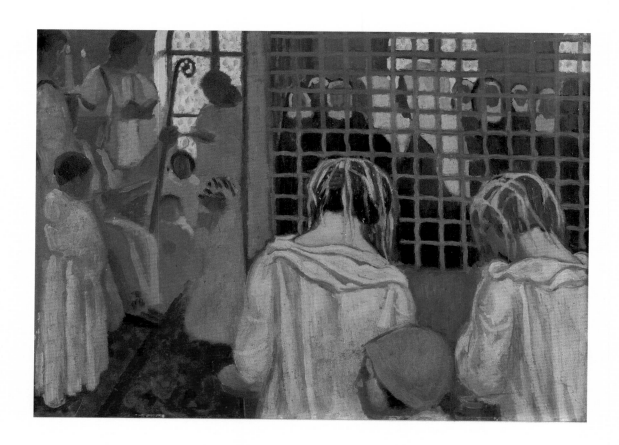

Dryness, sleep

At the start, all went well in the heart of Thérèse. Not a day went by without Louis Martin leaving a little present for his Carmelite daughters. But Monsieur Martin's mental health showed signs of deteriorating. Thérèse also experienced her limits and weaknesses, especially with regard to the community life, which often weighed on her. She was allowed to take the habit, but the date of the ceremony was postponed because Monsieur Martin's state worsened suddenly. The Martin daughters entered upon what Thérèse would call their "great trial," watching with intense sorrow as their father and beloved King lost his mind.

Ask Jesus to make me generous during my retreat. He is RIDDLING me with pin-pricks; the poor little ball is exhausted. All over it has very little holes which make it suffer more than if it had only one large one!... Nothing near Jesus. Aridity!... Sleep!... I would so much like to love him!... Love him more than he has ever been loved!... I WOULD LIKE TO CONVERT ALL THE SINNERS OF THIS EARTH AND TO SAVE ALL THE SOULS IN PURGATORY!...

Letter dated January 6, 1889, to Céline

On Saturday, June 23, 1888, Mr. Martin ran away from home for three days. On the 26th, while Céline went to look for him, the house next door to Martin's house was consumed by a fire which almost engulfed the Martin's house. The 27th, Mr. Martin is found in Le Havre by Céline and Uncle Guérin. At the beginning of July, Mr. Martin feels better and leaves with Céline to Auteuil to further her studies in painting.

They return and, in mid-August, Louis relapses. In this dramatic context, the clothing of Thérèse will nevertheless take place on January 10, 1889. Thérèse had just turned 16.

You are aware, dear Mother, of our bitter sufferings during the month of June, and especially June *24, 1888*. These memories are too deeply engraved in the bottom of our hearts to require any mention in writing. O Mother! how we suffered! And this was still only the *beginning* of the trial. The time for my reception of the habit had arrived. I was accepted by the conventual chapter, but how could we dream of any kind of ceremony? Already they were talking of giving me the habit without my going outside the cloister, and then they decided to wait. Against all expectation, our dear father recovered from his second attack, and the bishop set the ceremony for January 10. The wait had been long, but what a beautiful celebration it was! Nothing was missing, not even the snow!... The celebration, however, was wonderful. The most beautiful, the most attractive flower of all was my dear King; never had he looked so handsome, so *dignified*. Everybody admired him. This was really his day of *triumph* and it was to be his last celebration on this earth. He had now given all his children to God, for Céline too had confided her vocation to him. He had *wept tears of joy*, and had gone with her to thank him who "bestowed such honor on him by taking all his children."

January 10, as I have just said, was my King's day of triumph. I compare it to the entry of Jesus into Jerusalem on the day of the palms. Like that of our divine master, Papa's glory of a day was followed by a painful passion and this passion was not his alone. Just as the sufferings of Jesus pierced his Mother's heart with a sword of sorrow, so our hearts experienced the sufferings of the one we cherished most tenderly on earth. I recall that in the month of June, 1888, at the moment of our first trials, I said: "I am suffering very much, but I feel I can still bear greater trials." I was not thinking then of the ones reserved for me. I didn't know that on February 12, a month after my reception of the habit, our dear father would drink the most bitter and most humiliating of all chalices. Ah! that day, I didn't say I was able to suffer more!...

Just as the adorable face of Jesus was veiled during his Passion, so the face of his faithful servant had to be veiled in the days of his sufferings in order that it might shine in the heavenly Fatherland near its Lord, the Eternal Word!

The ceremony of clothing in which Thérèse took the habit took place on January 10, 1889, under the snow, after a very arid retreat. For one day nothing was missing in her joy. Even her father Louis was able to come. Thérèse added to her name "of the Child Jesus," which she had already chosen, the mystery of "the Holy Face [of Christ]."

On February 12, 1889, her father, Louis Martin, is interned at Bon-Sauveur psychiatric hospital.

The passion of our dear father

Look Jesus in the face

Letter dated April 4, 1889, to Céline

Dear little Céline,

Your letter gave great sadness to my soul! Poor little Papa!... No, the thoughts of Jesus are not our thoughts, and his ways are not our ways....

The other day, when reflecting on it, I found the secret of suffering in peace.... The one who says peace is not saying joy, or at least, felt joy.... To suffer in peace it is enough to will all that Jesus wills.... "A thousand years in your eyes, Lord, are as yesterday, which has PASSED"!...

Jesus is on fire with love for us... look at his adorable face!... Look at his eyes lifeless and lowered! Look at his wounds.... Look at Jesus in his face.... There you will see how he loves us.

Sister Thérèse of the Child Jesus
of the Holy Face

Georges Rouault, *Ecce homo*

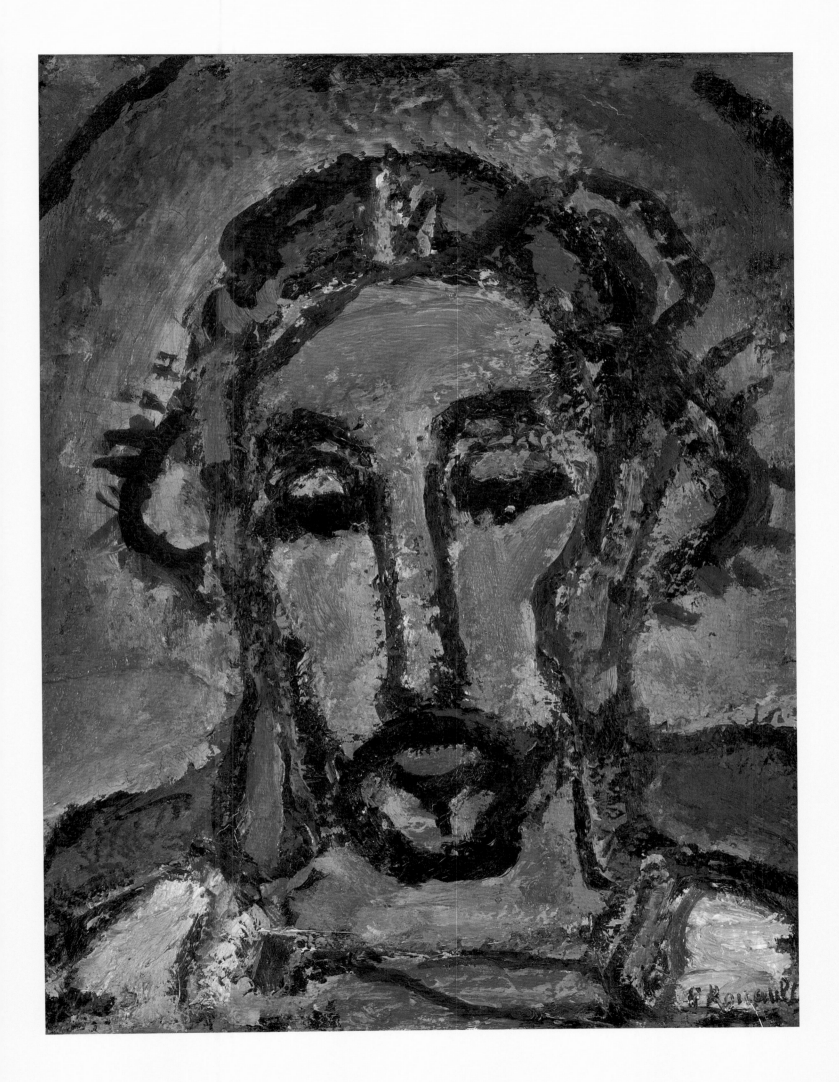

My only Homeland

Your Face is my only Homeland.
It's my Kingdom of love.
It's my cheerful Meadow,
Each day, my sweet Sun.
It's the Lily of the Valley
Whose mysterious perfume
Consoles my exiled soul,
Making it taste the peace of Heaven.

Your Face is my only wealth.
I ask for nothing more.
Hiding myself in it unceasingly,
I will resemble you, Jesus....
Leave in me the Divine impress
Of your Features filled with sweetness,
And soon I'll become holy.
I shall draw hearts to you.

One evening, after Compline, I was looking in vain for our lamp on the shelves reserved for this purpose. It was during the time of Great Silence and so it was impossible to complain to anyone about my loss. I understood that a sister, believing she was taking her lamp, picked up ours, which I really needed. Instead of feeling annoyed at being thus deprived of it, I was really happy, feeling that poverty consists in being deprived not only of agreeable things but of indispensable things too. And so in this exterior *darkness*, I was interiorly illumined!...

I was exerting much effort, too, at not excusing myself, which was very difficult for me.... Here was my first victory, not too great but it cost me a whole lot. A little vase set behind a window was broken, and our Mistress, thinking it was my fault, showed it to me and told me to be more careful in the future. Without a word, I kissed the floor, promising to be more careful in the future. Because of my lack of virtue these little practices cost me very much and I had to console myself with the thought that at the Last Judgment everything would be revealed....

I applied myself to practicing little virtues, not having the capability of practicing the great. For instance, I loved to fold up the mantles forgotten by the sisters, and to render them all sorts of little services.

Poverty of heart

A prayer of suffering

For a long time at evening meditation, I was placed in front of a sister who had a strange habit.... This is what I noticed: as soon as this sister arrived, she began making a strange little noise which resembled the noise one would make when rubbing two shells, one against the other. I was the only one to notice it because I had extremely sensitive hearing (too much so at times). Mother, it would be impossible for me to tell you how much this little noise wearied me. I had a great desire to turn my head and stare at the culprit, who was very certainly unaware of her "click." This would be the only way of enlightening her. However, in the bottom of my heart I felt it was much better to suffer this out of love for God and not to cause the sister any pain. I remained calm, therefore, and tried to unite myself to God and to forget the little noise. Everything was useless. I felt the perspiration inundate me, and I was obliged simply to make a prayer of suffering; however, while suffering, I searched for a way of doing it without annoyance and with peace and joy, at least in the interior of my soul. I tried to love the little noise which was so displeasing; instead of trying not to hear it (impossible), I paid close attention so as to hear it well, as though it were a delightful concert, and my prayer (which was not the Prayer of *Quiet*) was spent in offering this concert to Jesus.

Another time, I was in the laundry doing the washing in front of a sister who was throwing dirty water into my face every time she lifted the handkerchiefs to her bench; my first reaction was to draw back and wipe my face to show the sister who was sprinkling me that she would do me a favor to be more careful. But I immediately thought I would be very foolish to refuse these treasures which were being given to me so generously, and I took care not to show my struggle. I put forth all my efforts to desire receiving very much of this dirty water, and was so successful that in the end I had really taken a liking to this kind of aspersion, and I promised myself to return another time to this nice place where one received so many treasures.

My dear Mother, you can see that I am a very little soul and that I can offer God only very little things. It often happens that I allow these little sacrifices which give such peace to the soul to slip by; this does not discourage me, for I put up with having a little less peace and I try to be more vigilant on another occasion.

<div style="text-align:right">*Dirty water in my face*</div>

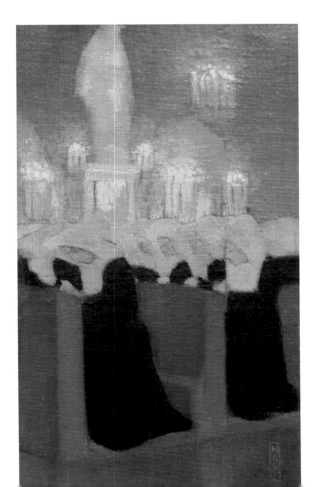

Weakness

Let us suffer the bitter pain, without courage!... (Jesus suffered in sadness! Without sadness would the soul suffer!...) And still we would like to suffer generously, grandly!... Céline! what an illusion!... We'd never want to fall?... What does it matter, my Jesus, if I fall at each moment; I see my weakness through this and this is a great gain for me.... You can see through this what I can do and now you will be more tempted to carry me in your arms.... If you do not do it, it is because this pleases you, to see me on the ground.... Then I am not going to be disturbed, but I shall always stretch out my arms suppliant and filled with love!... I cannot believe that you would abandon me!...

Letter dated April 26, 1889, to Céline

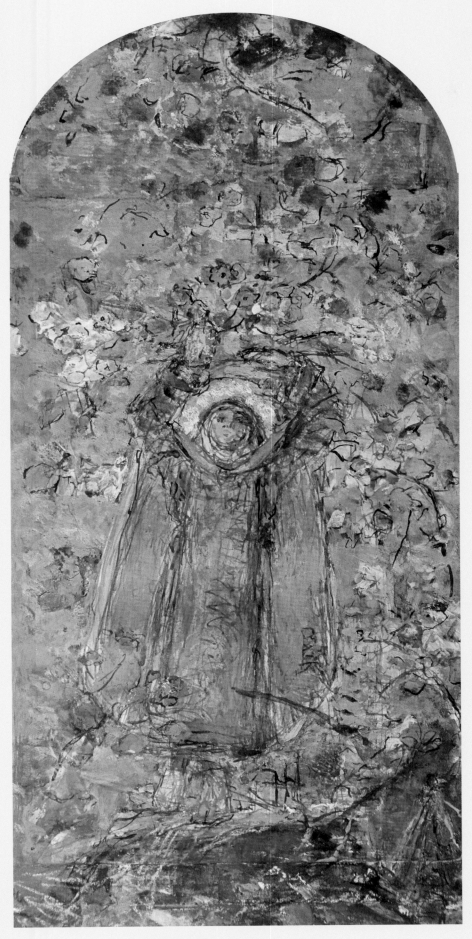

George Desvallières,
Saint Thérèse among Flowers

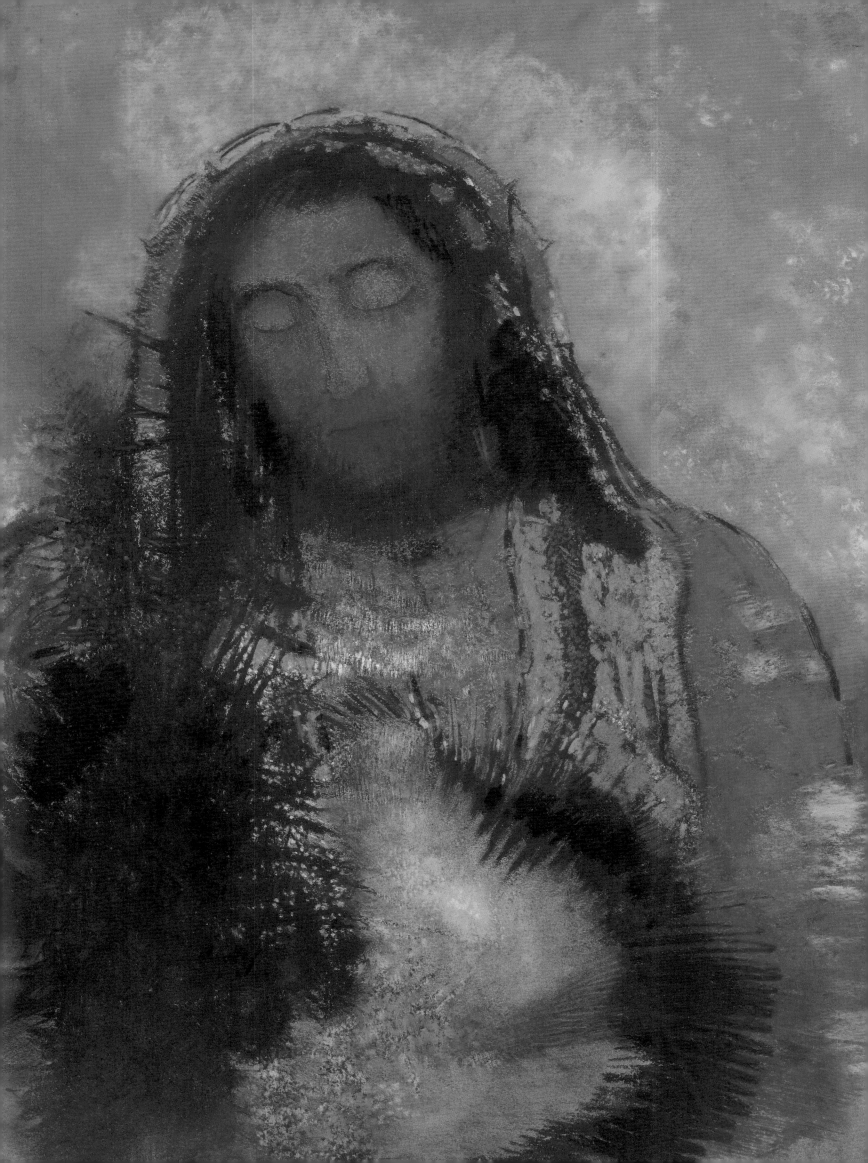

Marie, if you are nothing, you must not forget that Jesus is All, so you must lose your little nothingness in his infinite All and think only of this uniquely lovable All.... Neither ought you desire to see the fruit gathered from your efforts, for Jesus is pleased to keep for himself alone these little nothings that console him.... You are mistaken, my darling, if you believe that your little Thérèse walks always with fervor on the road of virtue. She is weak and very weak, and every day she has a new experience of this weakness, but, Marie, Jesus is pleased to teach her, as he did Saint Paul, the science of rejoicing in her infirmities. This is a great grace, and I beg Jesus to teach it to you, for peace and quiet of heart are to be found there only. When we see ourselves as so miserable, then we no longer wish to consider ourselves, and we look only on the unique Beloved!...

Dear little Marie, as for myself, I know no other means of reaching perfection but "love." ... Love, how well our heart is made for that!

Odilon Redon,
The Sacred Heart

Your little Thérèse is very weak

Letter dated July 27-29, 1890, to Marie Guérin

The retreat preceding my profession...was far from bringing me any consolations, since the most absolute aridity and almost total abandonment were my lot. Jesus was sleeping as usual in my little boat; ah! I see very well how rarely souls allow him to sleep peacefully within them. Jesus is so fatigued with always having to take the initiative and to attend to others that he hastens to take advantage of the repose I offer to him. He will undoubtedly awaken before my great eternal retreat, but instead of troubling me this only gives me extreme pleasure.

Really, I am far from being a saint, and what I have just said is proof of this; instead of rejoicing, for example, at my aridity, I should attribute it to my little fervor and lack of fidelity; I should be desolate for having slept (for seven years) during my hours of prayer and my *thanksgivings* after Holy Communion; well, I am not desolate. I remember that *little children* are as pleasing to their parents when they are asleep as well as when they are wide awake; I remember, too, that when they perform operations, doctors put their patients to sleep. Finally, I remember that "The Lord knows our weakness; he is mindful that we are but dust and ashes."

One year after she took the habit, Thérèse should have been allowed to make her profession. But instead of setting the date in the month of January, the superiors postponed it several months. The little fiancée finally became the bride of Jesus on September 8, 1890, after an absolutely arid retreat.

Jesus took me by the hand, and he made me enter a subterranean passage where it is neither cold nor hot, where the sun does not shine, and in which the rain or the wind does not visit, a subterranean passage where I see nothing but a half-veiled light, the light which was diffused by the lowered eyes of my Fiancé's face! My Fiancé says nothing to me, and I say nothing to him either except that I love him more than myself, and I feel at the bottom of my heart that it is true, for I am more his than my own!... The route that I follow has no consolation for me, and nevertheless it brings me all consolations since Jesus is the one who chose it.

I see nothing

Letter dated August 30-31, 1890, to Sister Agnes of Jesus

I don't understand the retreat I am making; I think of nothing, in a word, I am in a very dark subterranean passage!... Oh! ask Jesus...that he not permit souls to be deprived of lights that they need because of me, but that my darkness serve to enlighten them.... Ask him, too, that I make a good retreat and that he may be as pleased as he can be; then I too will be pleased, and I will consent, if this be his will, to walk all my life on the dark road that I am following, provided that one day I reach the summit of the mountain of Love. But I believe this will not be here below.

In the morning of September 8, I felt as though I were *flooded* with a river of peace, and it was in this *peace* "which surpasses all understanding" that I pronounced my holy vows. My union with Jesus was effected not in the midst of thunder and lightning, that is, in extraordinary graces, but in the bosom of a *light breeze* similar to the one our father Saint Elijah heard on the Mount. What graces I begged for on that day! I really felt I was the *Queen* and so I profited from my title by delivering captives, by obtaining favors from the *King* for his ungrateful subjects; finally, I wanted to deliver all the souls from purgatory and convert all sinners.

Profession

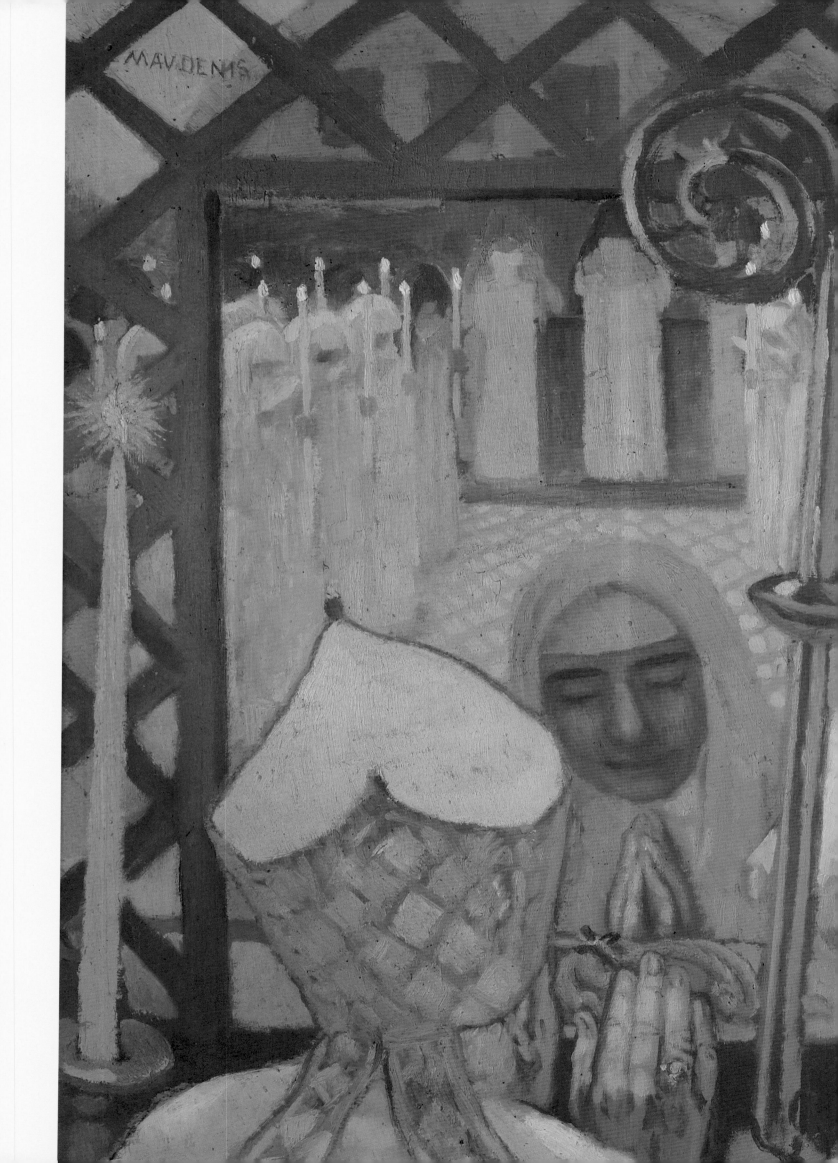

On September 24, 1890,
a few days after her religious
profession, Thérèse took
the black veil, sign of her
definitive commitment.

The ceremony of my reception of the veil took place on the 24th of September and the day was *veiled* in tears. Papa was not there to bless his queen; Father Pichon was in Canada; the bishop, who was supposed to come and dine with Uncle, did not come at all since he was sick. In a word, everything was sadness and bitterness. And still *peace*, always *peace*, reigned at the bottom of the chalice. That day, too, Jesus permitted that I was unable to hold back my tears and these were misunderstood. In fact, I had been able to bear up under much greater crosses without crying; however, this was because I was helped by powerful graces. Jesus left me to my own resources on the 24th and I soon showed how little these resources really were.

My very little resources

Maurice Denis,
After the Veil-taking

My weapon

Jesus, my only Love, how I love to strew Flowers
Each evening at the foot of your Crucifix!...
In unpetalling the springtime rose for you,
I would like to dry your tears....

Lord, my soul is in love with your beauty.
I want to squander my perfumes and my flowers on you.
In strewing them for you on the wings of the breeze,
I would like to inflame hearts!....

Strewing flowers, Jesus, is my weapon
When I want to fight to save sinners.
The victory is mine.... I always disarm you
With my flowers!!!...

Louis Martin had been hospitalized at
the Bon Sauveur since February 1889.
Communication with him was no longer
possible, except through silence, prayer,
and sacrifice. Céline watched over her
father. Léonie continued to seek her
path. Thérèse walked courageously in
the subterranean passage of dark faith
and fraternal charity, with no other light
but the love of Jesus.

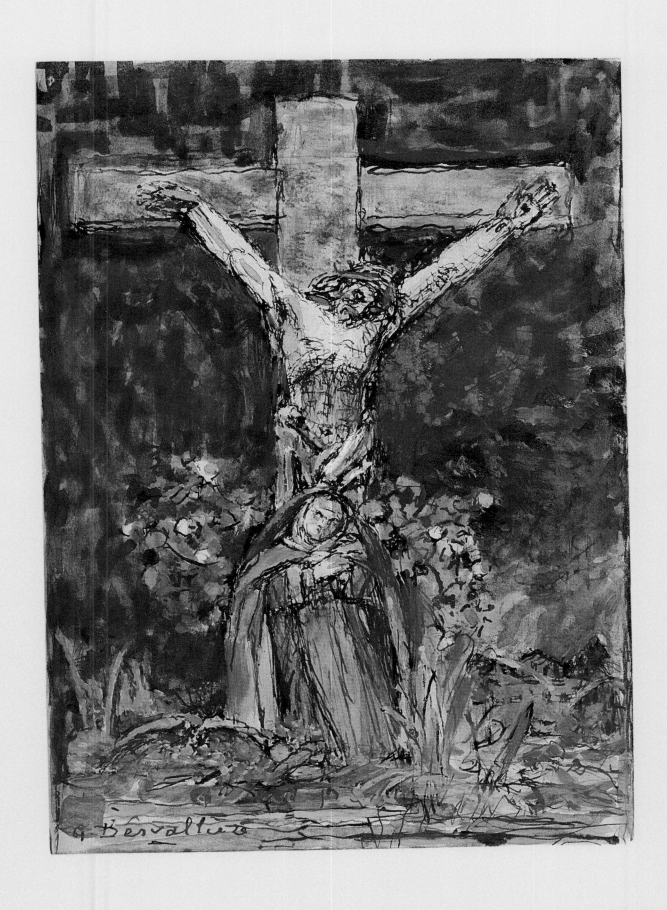

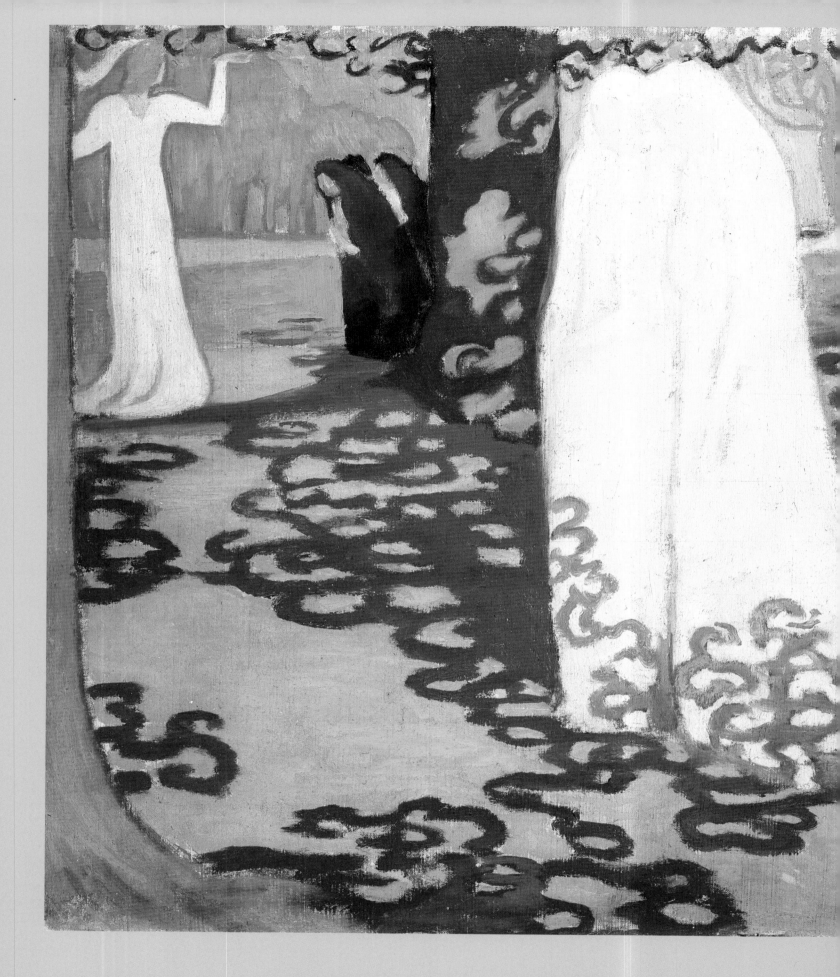

From the retreat with Father Alexis Prou
to the first signs of illness

VI. The light

October 1891 - Easter 1896

George Desvallières,
To Conquer the World

From 1890 to 1893, Thérèse continued her Carmelite formation in the novitiate.

From October 7 to 15, 1891, Thérèse made a retreat with Father Alexis Prou. She saw that he understood her and could even anticipate what she would say to him.... The priest confirmed her spiritual insight about trust and love and assured her that her faults caused the Good Lord no pain. A luminous time began for the young Carmelite.

Monsieur Martin, stricken with paralysis, returned to his family on May 10, 1892. Knowing that he was surrounded by his loved ones at home made the trial easier. His daughters saw him in the parlor one final time and heard his last words: "in Heaven!"

On September 8, 1893, the time of Thérèse's novitiate expired, but she asked for an extension of it. In fact, the Carmelite Rule does not allow three blood sisters to be together in one cloister. On February 20, 1893, Pauline (Mother Agnès de Jésus) was elected Prioress. During the winter of 1893 Thérèse caught cold and became hoarse. She had just turned 20.

O h! how happy I was to hear those consoling words! Never had I heard that our faults could not cause God any pain, and this assurance filled me with joy, helping me to bear patiently with life's exile. I felt at the bottom of my heart that this was really so, for God is more tender than a mother, and were you not, dear Mother, always ready to pardon the little offenses I committed against you involuntarily? How often I experienced this!... My nature was such that fear made me recoil; with love not only do I advance, I actually *fly*.

O Mother, it was especially since the blessed day of your election that I have flown in the ways of love. On that day Pauline became my living Jesus.

I have flown in the ways of love

erit does not consist in doing or in giving much, but rather in receiving, in loving much.... Let us allow him to take and give all he wills. Perfection consists in doing his will.... Oh, Céline, how easy it is to please Jesus, to delight his heart: one has only to love him, without looking at one's self, without examining one's faults too much. Your Thérèse is not in the heights at this moment, but Jesus is teaching her to learn "to draw profit from everything, from the good and the bad she finds in herself." He is teaching her to play at the bank of love, or rather he plays for her and does not tell her how he goes about it, for that is his affair and not Thérése's. What she must do is abandon herself, surrender herself, without keeping anything, not even the joy of knowing how much the bank is returning to her.

Since Thérèse entered the Carmel, her sister Céline took care of their father alone. Thérèse kept up a correspondence with Céline until she herself entered the Carmelite convent in Lisieux on September 14, 1894.

I have experienced it; when I am feeling nothing, when I am INCAPABLE of praying, of practicing virtue, then is the moment for seeking opportunities, nothings, which please Jesus more than mastery of the world or even martyrdom suffered with generosity. For example, a smile, a friendly word, when I would want to say nothing, or put on a look of annoyance....

When I do not have any opportunities, I want at least to tell him frequently that I love him; this is not difficult, and it keeps the fire going. Even though this fire of love would seem to me to have gone out, I would like to throw something on it, and Jesus could then relight it. Céline, I am afraid I have not said what I should; perhaps you will think I always do what I am saying. Oh, no! I am not always faithful, but I never get discouraged; I abandon myself into the arms of Jesus.

When Thérèse speaks of "fire," she means the fire of love.

I never get discouraged, I abandon myself

Letter dated July 18, 1893, to Céline

Do not fear, dear Céline, as long as your lyre does not cease to sing for Jesus, never will it break…. No doubt it is fragile, more fragile than crystal. If you were to give it to an inexperienced musician, soon it would break; but Jesus is the one who makes the lyre of your heart sound…. He is happy that you are feeling your weakness; he is the one placing in your soul sentiments of mistrust of itself. Dear Céline, thank Jesus. He grants you his choice graces; if always you remain faithful in pleasing him in little things he will find Himself OBLIGED to help you in GREAT things. The apostles worked all night without our Lord and they caught no fish, but their work was pleasing to Jesus. He willed to prove to them that he alone can give us something; he willed that the apostles humble themselves. "Children," he said to them, "have you nothing to eat?'" "Lord," Saint Peter answered, "we have fished all night and have caught nothing." Perhaps if he had caught some little fish, Jesus would not have performed the miracle, but he had nothing, so Jesus soon filled his net in such a way as almost to break it. This is the character of Jesus: He gives as God, but he wills humility of heart….

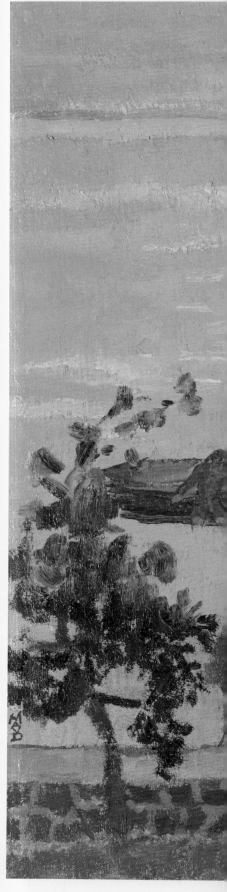

Maurice Denis,
The Miraculous Draught of Fishes

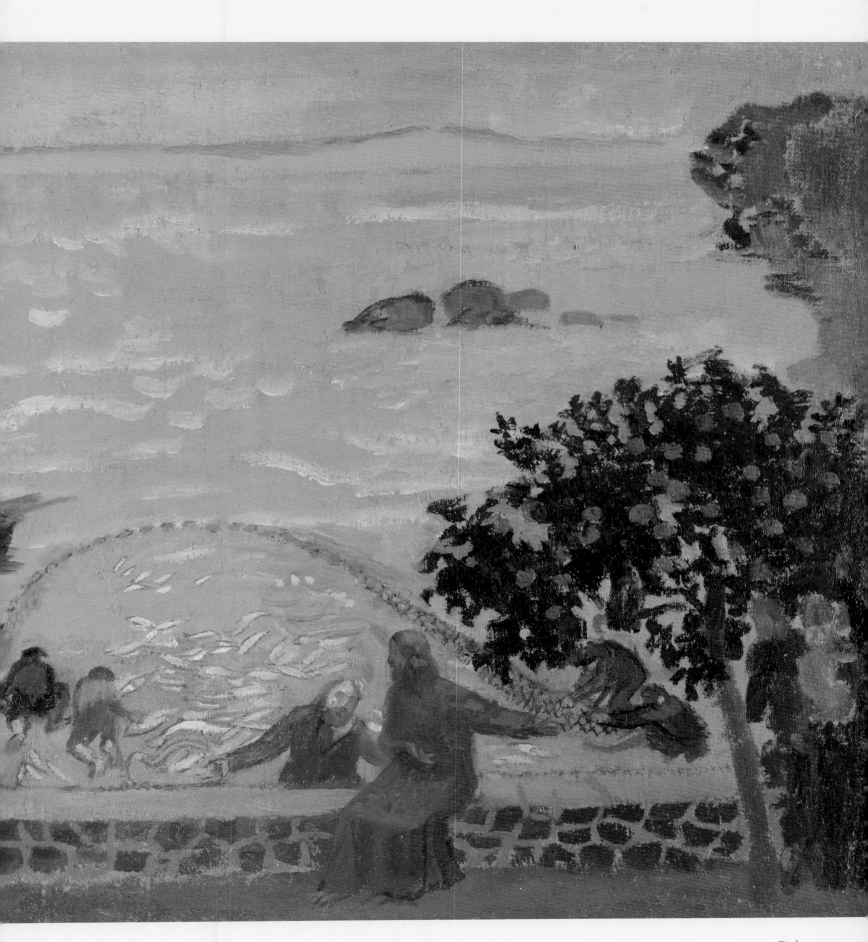

Who made you so little?

Inscription on a picture painted by Thérèse for Céline's 25th birthday in 1894

"Jesus,
who made you so little?
Love."

My life is but an instant, a passing hour.
My life is but a day that escapes and flies away.
O my God! You know that to love you on earth
I only have today!...

Oh, I love you, Jesus! My soul yearns for you.
For just one day remain my sweet support.
Come reign in my heart, give me your smile
Just for today!

Lord, what does it matter if the future is gloomy?
Oh pray for tomorrow, oh no, I cannot!...
keep my heart pure, cover me with your shadow
Just for today.

If I think about tomorrow, I fear my fickleness,
I feel sadness and worry rising up in my heart,
but I'm willing, my God, to accept trial and suffering
Just for today.

Lord, let me hide in your Face,
there I'll no longer hear the world's vain noise.
Give me your love, keep me in your grace
Just for today.

Just for today

My song for today, June 1, 1894

After her election to the priorate, Mother Agnes (Pauline Martin) appoints the former prioress, Mother Marie de Gonzague, as Mistress of Novices. And she gave her Sister Thérèse as her assistant. Thérèse would assume this responsibility until her death.

Fill my little hand

When I was given the office of entering into the sanctuary of souls, I saw immediately that the task was beyond my strength. I threw myself into the arms of God as a little child and, hiding my face in his hair, I said: "Lord, I am too little to nourish your children; if you wish to give through me what is suitable for each, fill my little hand and without leaving your arms or turning my head, I shall give your treasures to the soul who will come and ask for nourishment. If she finds it according to her taste, I shall know it is not to me but to you she owes it; on the contrary, if she complains and finds bitter what I present, my peace will not be disturbed, and I shall try to convince her this nourishment comes from you and be very careful not to seek any other for her."

Mother, from the moment I understood that it was impossible for me to do anything by myself, the task you imposed upon me no longer appeared difficult. I felt that the only thing necessary was to unite myself more and more to Jesus and that "all things will be given to you besides." In fact, never was my hope mistaken, for God saw fit to fill my little hand as many times as it was necessary for nourishing the soul of my Sisters.

And now I have no other desire except to love Jesus unto folly. My childish desires have all flown away. I still love to adorn the Infant Jesus' altar with flowers, but ever since he has given me the flower I desired, my *dear Céline*, I desire no other; she is the one I offer him as my most delightful bouquet.

Neither do I desire any longer suffering or death, and still I love them both; it is love alone that attracts me, however. I desired them for a long time; I possessed suffering and believed I had touched the shores of heaven, that the little flower would be gathered in the springtime of her life. Now, abandonment alone guides me. I have no other compass! I can no longer ask for anything with fervor except the accomplishment of God's will in my soul.... How sweet is the way of love, dear Mother. True, one can fall or commit infidelities, but, knowing how to *draw profit from everything*, love quickly consumes everything that can be displeasing to Jesus; it leaves nothing but a humble and profound peace in the depths of the heart.

On July 29, 1894, Monsieur Martin died, and on September 14 Céline rejoined her sisters at the Carmel. Thérèse felt immensely loved by God, who seemed to take pleasure in fulfilling all her dearest wishes. Thérèse is 21 years old. She begins to speak with confidence about her "little way."

Love alone is what attracts me

Living on Love

On the evening of Love, speaking without parable,
Jesus said: "If anyone wishes to love me
All his life, let him keep my Word.
My Father and I will come to visit him.
And we will make his heart our dwelling.
Coming to him, we shall love him always.
We want him to remain, filled with peace,
In our Love!..."

Living on Love is giving without limit
Without claiming any wages here below.
Ah! I give without counting, truly sure
That when one loves, one does not keep count!...
Overflowing with tenderness, I have given everything,
To his Divine Heart.... lightly I run.
I have nothing left but my only wealth:
Living on Love.

George Desvallières,
"Living on Love is giving without limit"

O my dear Mother! after so many graces can I not sing with the Psalmist: "How GOOD is the Lord, his MERCY endures forever!" It seems to me that if all creatures had received the same graces I received, God would be feared by none but would be loved to the point of folly; and through *love*, not through fear, no one would ever consent to cause him any pain. I understand, however, that all souls cannot be the same, that it is necessary there be different types in order to honor each of God's perfections in a particular way. To me he has granted his *infinite mercy*, and through it I contemplate and adore the other divine perfections! All of these perfections appear to be resplendent with *love*; even his justice (and perhaps this even more so than the others) seems to me clothed in love. What a sweet joy it is to think that God is *just*, i.e., that he takes into account our weakness, that he is perfectly aware of our fragile nature. What should I fear then? Ah! must not the infinitely just God, who deigns to pardon the faults of the prodigal son with so much kindness, be just also toward me who "am with him always"?

In June 1895 Thérèse offered herself as a victim of merciful Love, a decisive stage in her total abandonment to the love of God. From then on, she lived on Love.

This year, June 9, the feast of the Holy Trinity, I received the grace to understand more than ever before how much Jesus desires to be loved.

I was thinking about the souls who offer themselves as victims of God's justice in order to turn away the punishments reserved to sinners, drawing them upon themselves. This offering seemed great and very generous to me, but I was far from feeling attracted to making it. From the depths of my heart, I cried out: "O my God! Will your justice alone find souls willing to immolate themselves as victims? Does not your merciful love need them too? On every side this love is unknown, rejected; those hearts upon whom you would lavish it turn to creatures, seeking happiness from them with their miserable affection; they do this instead of throwing themselves into your arms and accepting your infinite *love*. O my God! Is your disdained love going to remain closed up within your heart? It seems to me that if you were to find souls offering themselves as victims of holocaust to your love, you would consume them rapidly; it seems to me, too, that you would be happy not to hold back the waves of infinite tenderness within you.... O my Jesus, let *me* be this happy victim; consume your holocaust with the fire of your divine love!" ...

Ah! since the happy day, it seems to me that *love* penetrates and surrounds me, that at each moment this *merciful love* renews me, purifying my soul and leaving no trace of sin within it.

In order to live in one single act of perfect Love, I OFFER MYSELF AS A VICTIM OF HOLOCAUST TO YOUR MERCIFUL LOVE, asking you to consume me incessantly, allowing the waves of *infinite tenderness* shut up within you to overflow into my soul, and that thus I may become a martyr of your love, O my God!...

May this martyrdom, after having prepared me to appear before you, finally cause me to die and may my soul take its flight without any delay into the eternal embrace of *your merciful love*.

I want, O my *Beloved*, at each beat of my heart to renew this offering to you an infinite number of times, until the shadows having disappeared I may be able to tell you of my love in an *eternal face-to-face*!...

On June 9, 1895, Thérèse was touched by the story of nuns who offered themselves as martyrs to divine justice, in order to divert upon themselves the punishments promised to the guilty. Thérèse says to herself that it is not to God's Justice that it is appropriate to offer oneself, but to his Mercy. And immediately, she composes her *Act of offering to the Merciful Love.*

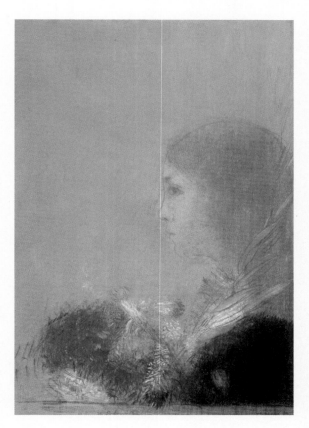

Banish all fear

Living on Love is banishing every fear,
Every memory of past faults.
I see no imprint of my sins.
In a moment love has burned everything
Divine Flame, O very sweet Blaze!
I make my home in your hearth.
In your fire I gladly sing:
"I live on Love!..."

Living on Love is keeping within oneself
A great treasure in an earthen vase.
My Beloved, my weakness is extreme.
Ah, I'm far from being an angel from
heaven!...
But if I fall with each passing hour,
You come to my aid, lifting me up.
At each moment you give me your grace:
I live on Love.

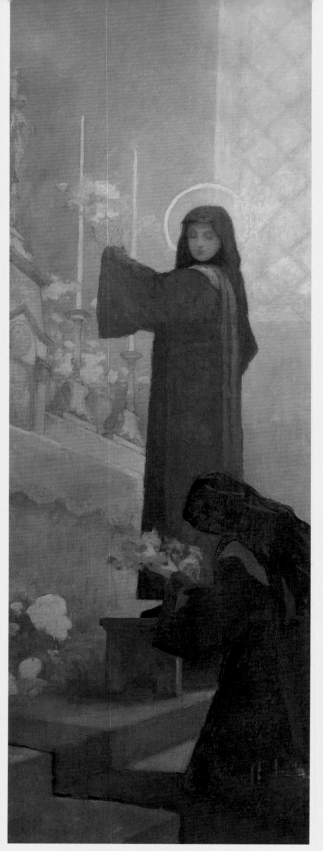

Amédée Buffet,
Saint Thérèse in the Carmel

I understood how imperfect was my love for my Sisters. I saw I didn't love them as God loves them. Ah! I understand now that charity consists in bearing with the faults of others, in not being surprised at their weakness, in being edified by the smallest acts of virtue we see them practice....

There is in the community a sister who has the faculty of displeasing me in everything, in her ways, her words, her character; everything seems very *disagreeable* to me. And still, she is a holy religious who must be *very pleasing* to God. Not wishing to give in to the natural antipathy I was experiencing, I told myself that charity must not consist in feelings but in works; then I set myself to doing for this sister what I would do for the person I loved the most. Each time I met her I prayed to God for her, offering him all her virtues and merits. I felt this was pleasing to Jesus, for there is no artist who doesn't love to receive praise for his works, and Jesus, the Artist of souls, is happy when we don't stop at the exterior, but, penetrating into the inner sanctuary where he chooses to dwell, we admire its beauty. I wasn't content simply with praying very much for this sister who gave me so many struggles, but I took care to render her all the services possible, and when I was tempted to answer her back in a disagreeable manner, I was content with giving her my most friendly smile.

O my Jesus! I thank you for having fulfilled one of my greatest desires, that of having a brother, a priest, an apostle.... I feel very unworthy of this favor. And yet, since you grant your little spouse the grace of working specially for the sanctification of a soul destined for the priesthood, I offer you joyfully all the prayers and sacrifices at my disposal. I ask you, o my God: not to look at what I am but what I should be and want to be, a religious wholly inflamed with your love.

On October 7, 1895, Mother Agnes entrusted to Thérèse her first spiritual brother: Father Bellière.

A brother priest

I live on Love

Living on Love, O my Divine Master,
Is begging you to spread your Fire
In the holy, sacred soul of your Priest.
May he be purer than a seraphim in Heaven!...
Ah! glorify your Immortal Church!
Jesus, do not be deaf to my sighs.
I, her child, sacrifice myself for her,
I live on Love.

Living on Love is wiping your Face,
It's obtaining the pardon of sinners.
O God of Love! may they return to your grace,
And may they forever bless your Name
Even in my heart the blasphemy resounds.
To efface it, I always want to sing:
"I adore and love your Sacred Name.
I live on Love!..."

From the first symptoms
to the death of Thérèse

Easter 1896 -
September 30, 1897

Gustave Moreau,
Christ in the Garden of Olives

VII. *The darkness*

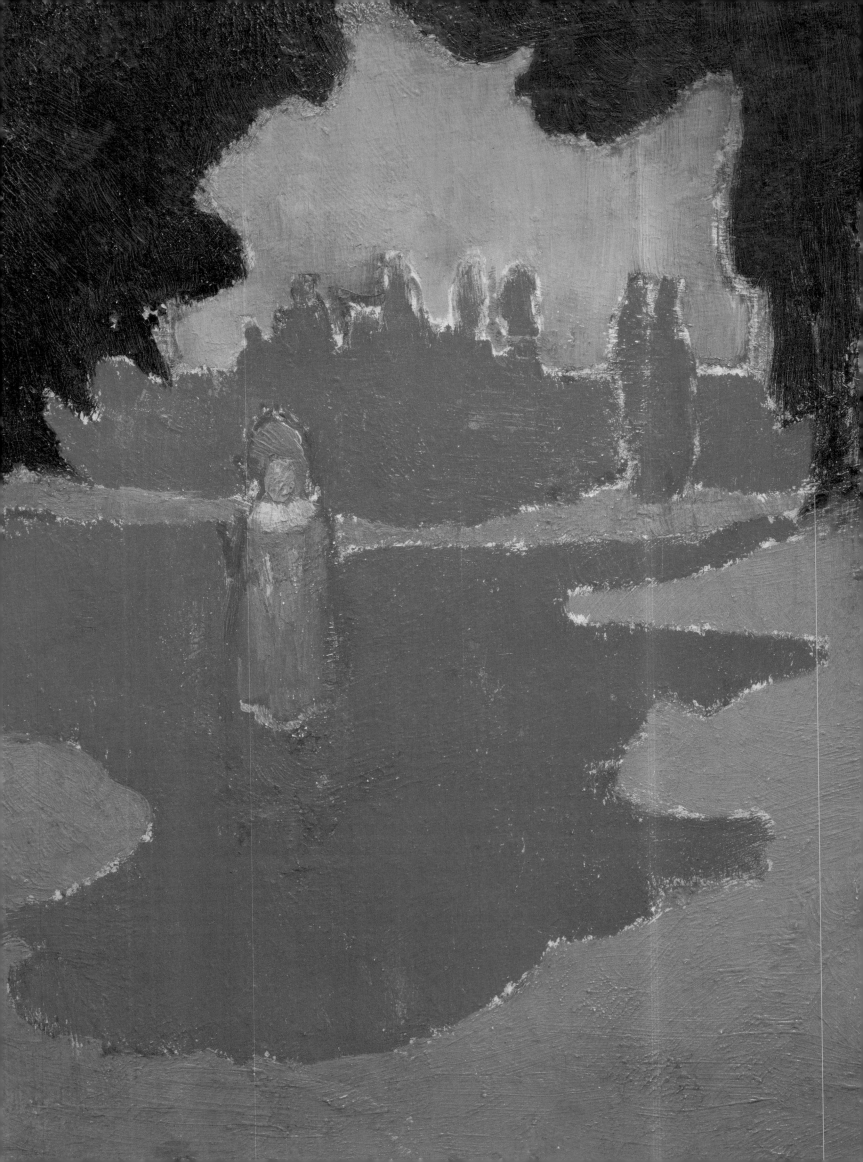

God granted me, last year, the consolation of observing the fast during Lent in all its rigor. Never had I felt so strong, and this strength remained with me until Easter. On Good Friday, however, Jesus wished to give me the hope of going to see him soon in heaven. Oh! how sweet this memory really is! After remaining at the Tomb until midnight, I returned to our cell, but I had scarcely laid my head upon the pillow when I felt something like a bubbling stream mounting to my lips. I didn't know what it was, but I thought that perhaps I was going to die and my soul was flooded with joy. However, as our lamp was extinguished, I told myself I would have to wait until the morning to be certain of my good fortune, for it seemed to me that it was blood I had coughed up. The morning was not long in coming; upon awakening, I thought immediately of the joyful thing that I had to learn, and so I went over to the window. I was able to see that I was not mistaken. Ah! my soul was filled with a great consolation; I was interiorly persuaded that Jesus, on the anniversary of his own death, wanted to have me hear his first call. It was like a sweet and distant murmur that announced the Bridegroom's arrival.

In the Spring of 1896, Mother Marie de Gonzague was once again elected prioress of the community. She asked Thérèse to become mistress of novices. She did not accept the title but took on the responsibility until her death. From that day on, Thérèse met each day with the five young sisters for a half-hour talk. The rest of the time she was in the sacristy, painting, or working in the laundry.

During the night from April 2 to 3, 1896, that is from Holy Thursday to Good Friday, Thérèse coughed up blood. These were the first pulmonary hemorrhages indicating the tuberculosis that would slowly consume her.

Maurice Denis,
Sun Spot on the Terrace

A first call, the arrival of the Bridegroom

The gloomy tunnel

A few days later, however, amid the joy of Easter 1896, Thérèse felt that she had been invaded by the thickest darkness. The thought of heaven became for her the cause of struggle and torment. It was the night of faith.

During those very joyful days of the Easter season, Jesus made me feel that there were really souls who have no faith.... He permitted my soul to be invaded by the thickest darkness, and that the thought of heaven, up until then so sweet to me, be no longer anything but the cause of struggle and torment. This trial was to last not a few days or a few weeks, it was not to be extinguished until the hour set by God himself, and this hour has not yet come. I would like to be able to express what I feel, but alas! I believe this is impossible. One would have to travel through this dark tunnel to understand its darkness.

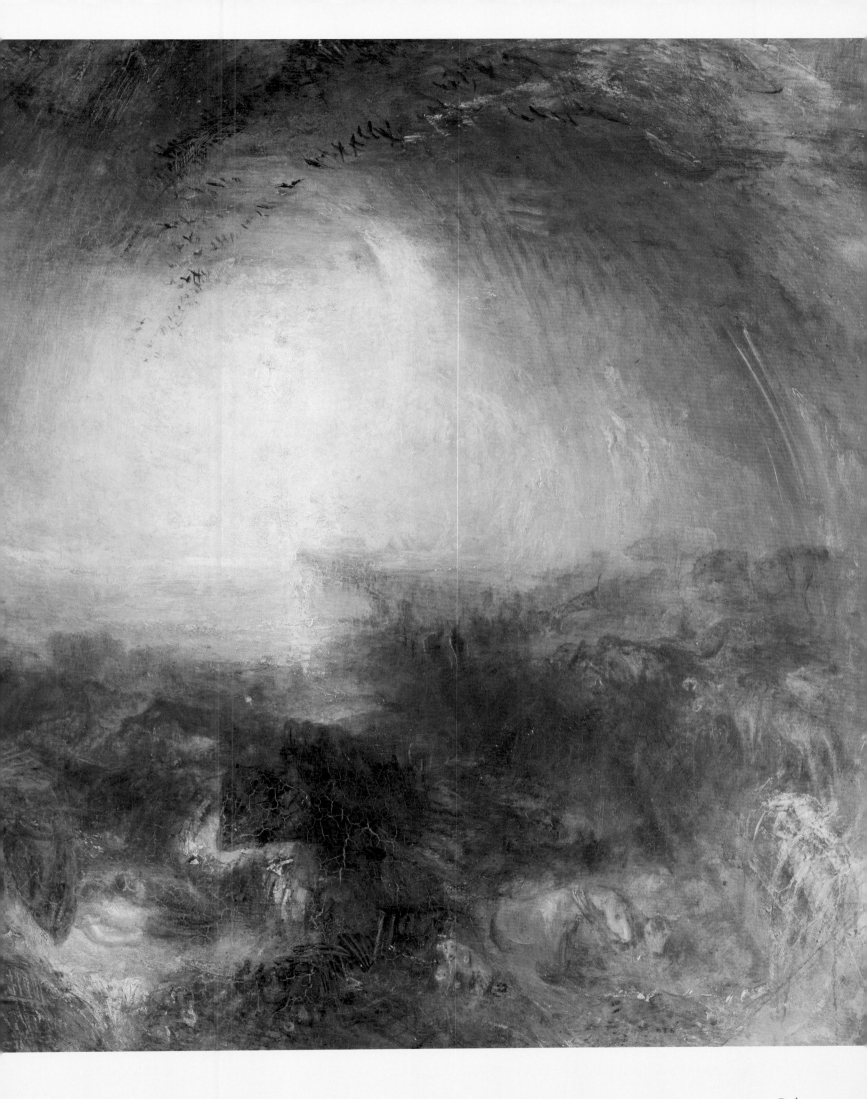

At the sinners' table

Your child, however, O Lord, has understood your divine light, and she begs pardon for her brothers. She is resigned to eat the bread of sorrow as long as you desire it; she does not wish to rise up from this table filled with bitterness at which poor sinners are eating until the day set by you. Can she not say in her name and in the name of her brothers, "Have pity on us, O Lord, for we are poor sinners!" Oh! Lord, send us away justified. May all who were not enlightened by the bright flame of faith one day see it shine. O Jesus! if it is needful that the table soiled by them be purified by a soul who loves you, then I desire to eat this bread of trial at this table until it pleases you to bring me into your bright Kingdom. The only grace I ask of you is that I never offend you!

When I want to rest my heart, fatigued by the darkness that surrounds it, by the memory of the luminous country after which I aspire, my torment redoubles; it seems to me that the darkness, borrowing the voice of sinners, says mockingly to me: "You are dreaming about the light, about a fatherland embalmed in the sweetest perfumes; you are dreaming about the *eternal* possession of the Creator of all these marvels; you believe that one day you will walk out of this fog that surrounds you! Advance, advance; rejoice in death, which will give you not what you hope for but a night still more profound, the night of nothingness."

Dear Mother, the image I wanted to give you of the darkness that obscures my soul is as imperfect as a sketch is to the model; however, I don't want to write any longer about it; I fear I might blaspheme; I fear even that I have already said too much.

The night of nothingness

Ah! may Jesus pardon me if I have caused him any pain, but he knows very well that while I do not have the joy of faith, I am trying to carry out its works at least. I believe I have made more acts of faith in this past year than all through my whole life. At each new occasion of combat, when my enemies provoke me, I conduct myself bravely. Knowing it is cowardly to enter into a duel, I turn my back on my adversaries without deigning to look them in the face; but I run toward my Jesus. I tell him I am ready to shed my blood to the last drop to profess my faith in the existence of heaven. I tell him, too, I am happy not to enjoy this beautiful heaven on this earth so that he will open it for all eternity to poor unbelievers. Also, in spite of this trial which has taken away *all my joy*, I can nevertheless cry out: "You have given me *DELIGHT*, O Lord, in ALL your doings."

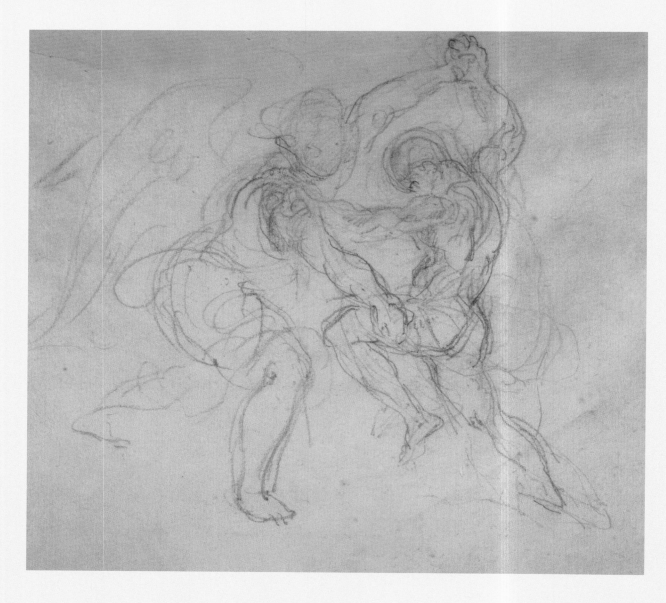

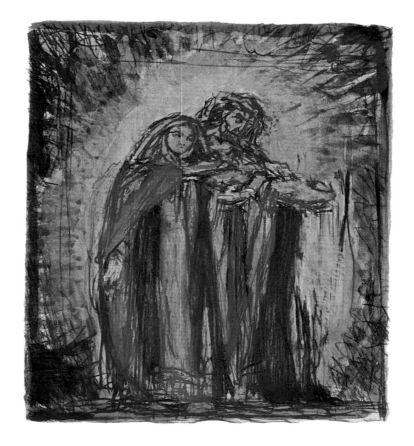

When the blue Sky becomes somber
And begins to abandon me,
My joy is to stay in the shadow
To hide and humble myself.
My joy is the Holy Will
Of Jesus, my only love,
So I live without any fear.
I love the night as much as the day.

My joy is to stay little,
So when I fall on the way,
I can get up very quickly,
And Jesus takes me by the hand.
Then I cover him with caresses
And tell Him He's everything for me,
And I'm twice as tender
When He slips away from my faith.

I love the night as much as the day

My joy!

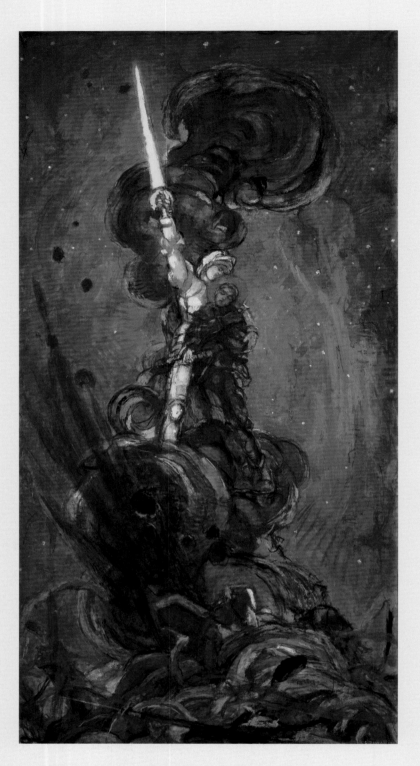

On May 30, 1896, Mother Marie de Gonzague entrusted to Thérèse another little Brother, a missionary of the Paris Foreign Missions Society, Father Roulland. In September 1896, Thérèse wrote a letter to Sister Marie of the Sacred Heart, who had asked her to share with her the lights that she had received from her retreat. At the heart of the dark night, Thérèse found her vocation: it was Love.

To be your spouse, to be a *Carmelite*, and by my union with you to be the *mother* of souls, should not this suffice me? And yet it is not so. No doubt, these three privileges sum up my true vocation: *Carmelite*, *spouse*, *mother*, and yet I feel within me other *vocations*. I feel the *vocation* of the WARRIOR, THE PRIEST, THE APOSTLE, THE DOCTOR, THE MARTYR. Finally, I feel the need and the desire of carrying out the most heroic deeds for *you, O Jesus*. I feel within my soul the courage of the *crusader*, the *papal guard*, and I would want to die on the field of battle in defense of the Church.

I feel in me the vocation of the PRIEST. With what love, O Jesus, I would carry you in my hands when, at my voice, you would come down from heaven. And with what love would I give you to souls!... O Jesus, my Love, my Life, how can I combine these contrasts? How can I realize the desires of my poor *little soul*?

During my meditation, my desires caused me a veritable martyrdom, and I opened the Epistles of Saint Paul to find some kind of answer. Chapters 12 and 13 of the First Epistle to the Corinthians fell under my eyes. I read there, in the first of these chapters, that all cannot be apostles, prophets, doctors, etc., that the Church is composed of different members, and that the eye cannot be the hand at one and the same time.... I continued my reading, and this sentence consoled me: *"Yet strive after* THE BETTER GIFTS, *and I point out to you a yet* more excellent way." And the Apostle explains how all the most PERFECT gifts are nothing without LOVE. That *Charity is the EXCELLENT WAY* that leads most surely to God.

I finally had rest. Considering the mystical body of the Church, I had not recognized myself in any of the members described by Saint Paul, or rather I desired to see myself in them *all. Charity* gave me the key to my *vocation*. I understood that if the Church had a body composed of different members...the Church *had a Heart and...this heart was BURNING WITH LOVE. I understood it was Love alone* that made the Church's members act, that if *Love* ever became extinct, apostles would not preach the Gospel and martyrs would not shed their blood. I understood that LOVE COMPRISED ALL VOCATIONS, THAT LOVE WAS EVERYTHING, THAT IT EMBRACED ALL TIMES AND PLACES.... IN A WORD, THAT IT WAS ETERNAL!

I understood

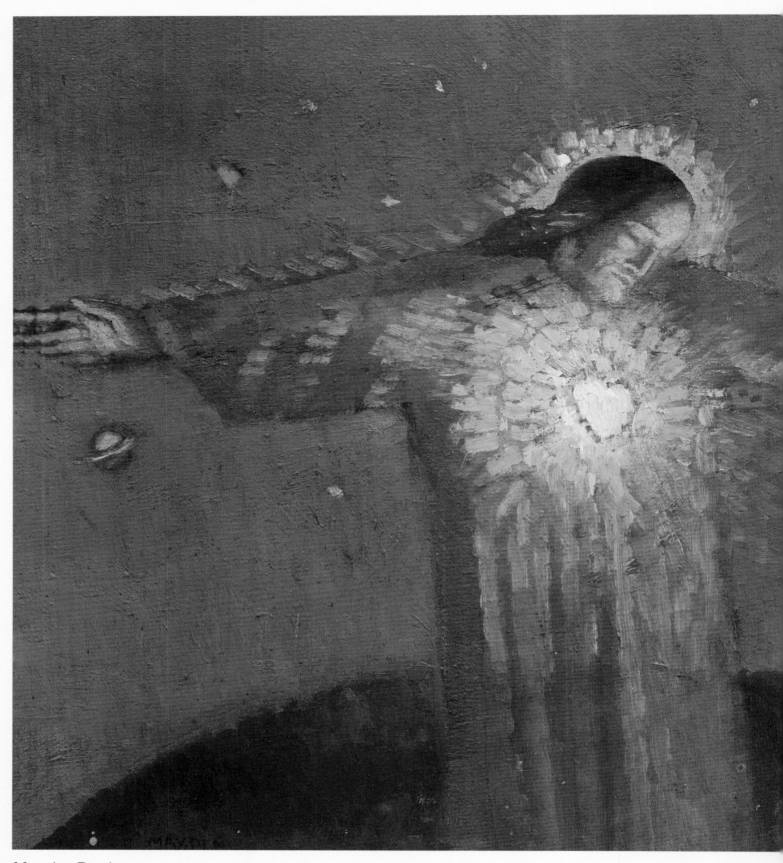

Maurice Denis,
Sacred Heart, with Starry Sky

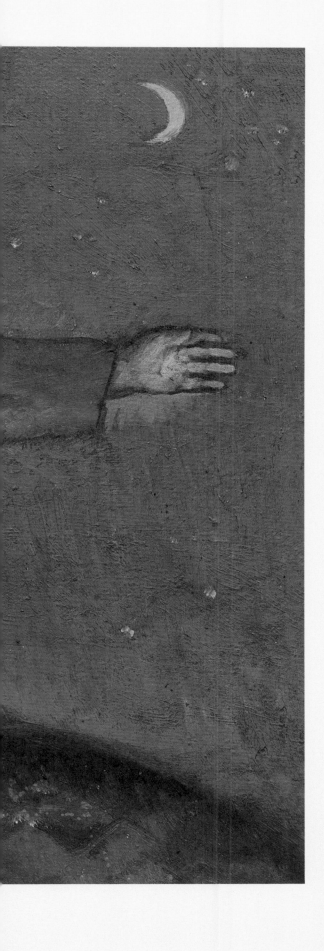

My vocation is Love

Then, in the excess of
my delirious joy, I cried out:
O Jesus, my Love....
My vocation, at last I have
found it.... MY VOCATION IS LOVE!

My desires of martyrdom are nothing.... Ah! I really feel that it is not this at all that pleases God in my little soul; what pleases him is that he sees me loving my littleness and my poverty, the blind hope that I have in his mercy.... Let us remain then very far from all that sparkles, let us love our littleness, let us love to feel nothing; then we shall be poor in spirit, and Jesus will come to look for us, and however far we may be, he will transform us in flames of love....

Oh! how I would like to be able to make you understand what I feel!... It is confidence and nothing but confidence that must lead us to Love.... Jesus...wills to give us his heaven gratuitously.

Letter dated September 17, 1896, to Sister Marie of the Sacred Heart

To tell the truth, spiritual riches
are what *render* a person *unjust*,
when one rests in them with
complacence and when one believes
they are *something great*....

Letter dated September 17, 1896, to Sister Marie of the Sacred Heart

The poorer you are

The poorer you are the more
Jesus will love you. He will go far,
very far, in search of you,
if at times you wander off a little.

Christmas Letter, 1896, to Sister Geneviève

In October 1896, Father Godefroy Madeleine gave a community retreat. Thérèse confided to him her temptations against faith. The Premonstratensian friar advised her to keep the Creed constantly on her heart. Thérèse wrote it with her blood.

During the winter of 1896–1897, Thérèse's health declined. In April 1897, signs of tuberculosis were now evident: face flushed with fever, lack of appetite, exhaustion. She could hardly stand but kept trying to walk "for a missionary." Little by little she was relieved of her duties. From April 6 on, Mother Agnes (Pauline) began to record the words of her sister in the Yellow Notebook.

I don't want to die more than to live; that is, if I had the choice, I would prefer to die. But since it's God who makes the choice for me, I prefer what he wills. It's what he does that I love.

It's what he does that I love

Yellow Notebook, May 27, 1897

On June 9, 1897, Thérèse was thought
to be dying. Then the disease went
into remission. Thérèse continued
to write Manuscript C at the request
of Mother Marie de Gonzague.

Dear little Brother,

I received your letter this morning, and I am profiting from a moment when the infirmarian is absent to write you a last note of adieu. When you receive it, I shall have left the exile.... Your little sister will be united forever to her Jesus; then she will be able to obtain graces for you and to fly with you into distant missions.... Dear little Brother, I would like to tell you many things that I understand now that I am at the door of eternity; but I am not dying, I am entering into Life, and all that I cannot say to you here below I will make you understand from the heights of heaven...

Adieu, little Brother, pray for your little sister who says to you: See you soon in heaven!

I have my weaknesses also, but I rejoice in them. I don't always succeed in rising above the nothings of this earth; for example, I will be tormented by a foolish thing I said or did. Then I enter into myself, and I say: Alas, I'm still at the same place as I was formerly! But I tell myself this with great gentleness and without any sadness! It's so good to feel that one is weak and little! Don't be sad about seeing me sick, little Mother, for you can see how happy God makes me.

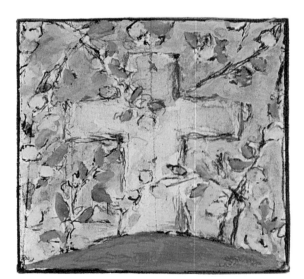

I rejoice in my weaknesses

I need mercy so much!

Oh, how happy I am to see myself imperfect and to have such need of God's mercy at the moment of my death!

On July 6, 1897, the pulmonary hemorrhages resumed. Thérèse was taken to the infirmary. From August 25 until September 30 she suffered terribly and could speak very little.

Yellow Notebook, July 29, 1897

Ah! she believed I was looking at the sky
and thinking of the real heavens!
No, it was simply because I admire
the material heavens; the other
is closed against me more and more.

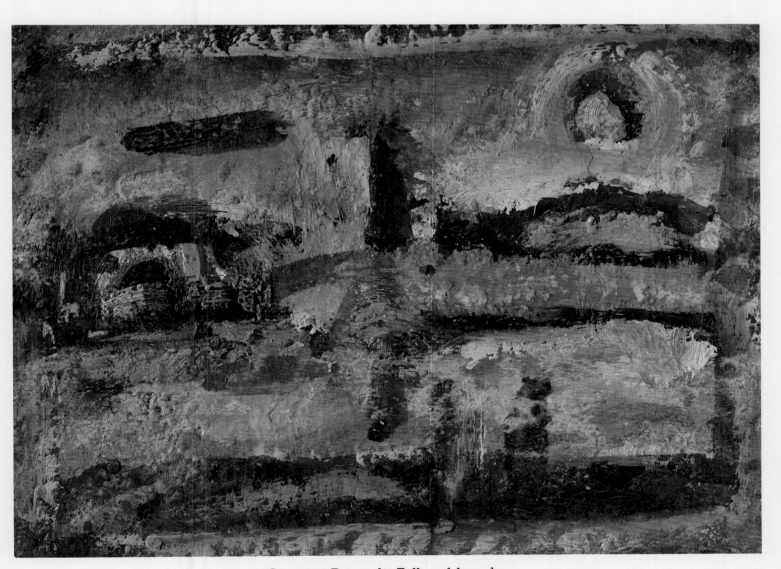

Georges Rouault, *Fall, golden sky*.

Yellow Notebook, August 8, 1897

No, I'm not a saint; I've never performed the actions of a saint. I'm a very little soul upon whom God has bestowed graces; that's what I am. What I say is the truth; you'll see this in heaven.

And the saints, where are they, then?

I wonder how God can hold himself back for such a long time from taking me.... And then, one would say that he wants to make me "believe" that there is no heaven!... And all the saints whom I love so much, where are they "hanging out"?... Ah! I'm not pretending, it's very true that I don't see a thing. But I must sing very strongly in my heart: "After death life is immortal," or without this, things would turn out badly....

I can only say: Jesus!

I can no longer pray!
I can only look at the
Blessed Virgin and say:
"Jesus!"

Last Words with Céline, August 6, 1897

Besides her great difficulty breathing, Thérèse was afflicted with terrible internal pains. Her bodily functions were now accompanied by great sufferings. If they sat her up to relieve her cough, she felt as though she were sitting "on iron spears." She begged them to pray for her because, she said, "it's enough to make you lose your mind."

On August 27, Thérèse suffered extreme thirst. "I am never quenched," she said. "If I drink, the thirst increases. It is as though I poured fire inside." Every morning her tongue was so dried out that it looked like a piece of wood.

I'm afraid I've feared death, but I won't fear it after it takes place; I'm sure of this! And I'm not sorry for having lived; oh! no. It's only when I ask myself: What is this mysterious separation of the soul from the body? It's my first experience of this, but I abandon myself to God.

I am afraid that I have feared

Yellow Notebook, September 11, 1897

159

Yes! What a grace it is to have faith!
If I had not had any faith,
I would have committed suicide
without an instant's hesitation....

George Desvallières, *Temptations*

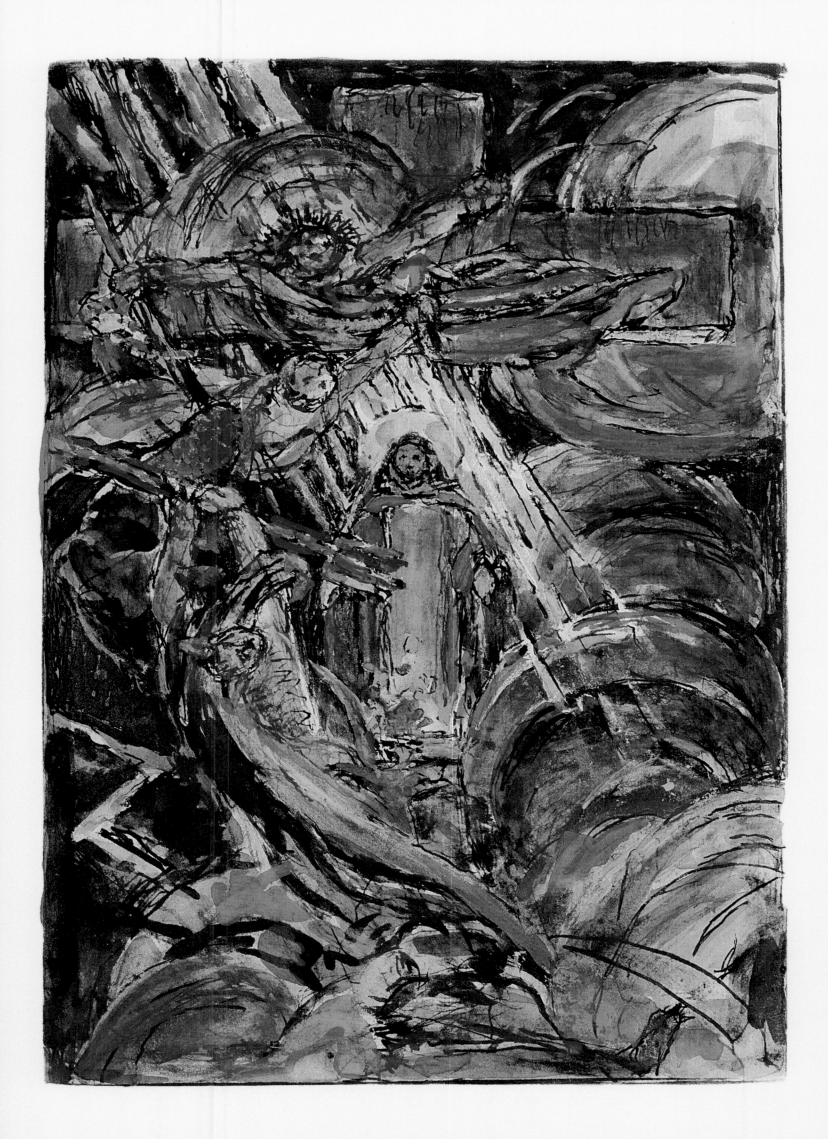

Oh! how much I owe you!...
Also, how I love you!...but I don't
want to talk about it anymore
because I would cry....

Mother, is this the agony?...
What must I do to die?
Never will I know how to die!

Never will I know how to die!

Yellow Notebook, September 29, 1897

I am not sorry for delivering myself up to Love

During the night from September 29 to 30, Thérèse again wished to remain alone. She did not want anyone to keep watch over her through the night. But Sister Marie of the Sacred Heart (Marie) and Sister Geneviève (Céline) succeeded in getting permission to remain beside her. Thérèse's sole concern was not to trouble her sisters' rest.

I am not sorry for delivering myself up to Love. Oh! no, I'm not sorry; on the contrary! Never would I have believed it was possible to suffer so much! never! never! I cannot explain this except by the ardent desires I have had to save souls.

Towards five o'clock on Tuesday, September 30, Thérèse's face changed. The community came to her bedside. She greeted all the sisters with a sweet smile. She was holding her crucifix and looked at it constantly. Perspiration beaded her forehead. Finding it increasingly difficult to breathe, she made little involuntary cries. Outside the birds sang.

Oh! I love him!...
My God... I love you!...

Mother Mary of Gonzague had the infirmary bell rung and said to open all the doors. Mother Agnes (Pauline) thought that the angels of heaven must be doing the same: opening all the doors for little Thérèse who was about to enter. The sisters knelt around the bed. Thérèse's face had regained its lily-white complexion. Her eyes were fixed above, gleaming with peace and joy. This ecstasy lasted for the space of a *Credo*. Then she gave her last breath.

My God... I love you

Dying of Love

Dying of Love is a truly sweet martyrdom,
And that is the one I wish to suffer.
O Cherubim! Tune your lyre,
For I sense my exile is about to end!...
Flame of Love, consume me unceasingly.
Life of an instant, your burden is so heavy to me!
Divine Jesus, make my dream come true:
To die of Love!...

Dying of Love is what I hope for.
When I shall see my bonds broken,
My God will be my Great Reward.
I don't desire to possess other goods.
I want to be set on fire with his Love.
I want to see Him, to unite myself to Him forever.
That is my Heaven... that is my destiny:
Living on Love!!!

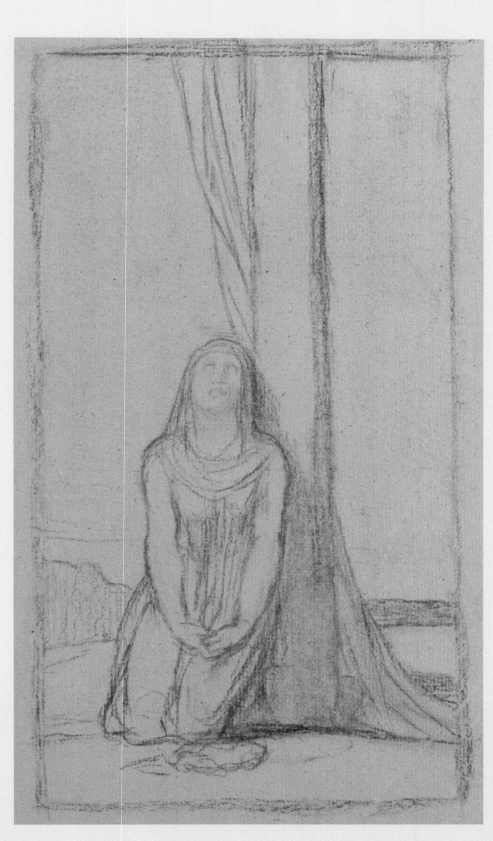

Hippolyte Flandrin,
Magdalene at the Foot of the Cross

Amédée Buffet, *Christ making it rain roses on the body of Saint Thérèse*

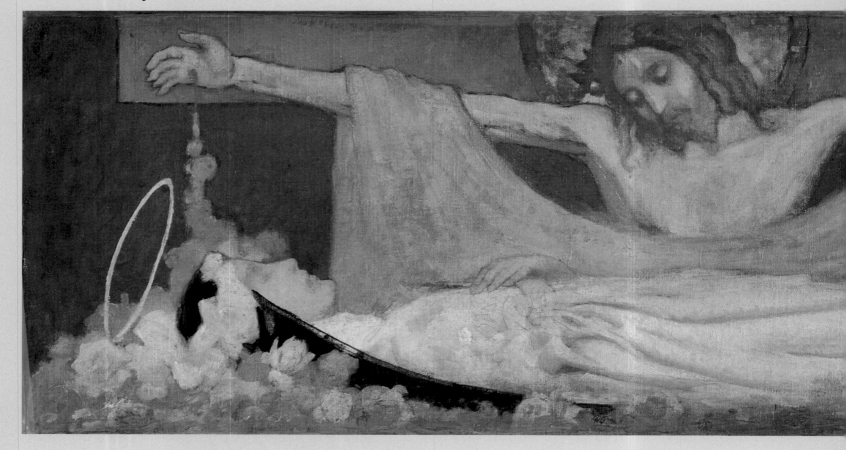

VIII. *The little way*

George Desvallières,
*Saint Thérèse
Watching over France*

Yellow Notebook, July 17, 1897

Thérèse promised that she would spend her heaven doing good on earth, that she would give her little way to souls. She has not stopped putting this into practice since September 30, 1897. Countless graces have been obtained through her intercession, and the "little way" does not cease to bear spiritual fruit.

I feel that I'm about to enter into my rest. But I feel especially that my mission is about to begin, my mission of making God loved as I love him, of giving my little way to souls. If God answers my desires, my heaven will be spent on earth until the end of the world. Yes, I want to spend my heaven in doing good on earth.

Don't believe that when I'm in heaven I'll let ripe plums fall into your mouths. This isn't what I had, nor what I desired. You will perhaps have great trials, but I'll send you lights which will make you appreciate and love them. You will be obliged to say like me: "Lord, you fill us with joy with all the things you do for us."

Ripe plums

The little way

You know, Mother, I have always wanted to be a saint. Alas! I have always noticed that when I compared myself to the saints, there is between them and me the same difference that exists between a mountain whose summit is lost in the clouds and the obscure grain of sand trampled underfoot by passersby. Instead of becoming discouraged, I said to myself: God cannot inspire unrealizable desires. I can, then, in spite of my littleness, aspire to holiness. It is impossible for me to grow up, and so I must bear with myself as I am, with all my imperfections. But I want to seek out a means of going to heaven by a little way, a way that is very straight, very short, and totally new.

We are living now in an age of inventions, and we no longer have to take the trouble of climbing stairs, for, in the homes of the rich, an elevator has replaced these very successfully. I wanted to find an elevator which would raise me to Jesus, for I am too small to climb the rough stairway of perfection. I searched, then, in the Scriptures for some sign of this elevator, the object of my desires, and I read these words coming from the mouth of Eternal Wisdom: *"Whoever is a LITTLE ONE, let him come to me."* And so I succeeded. I felt I had found what I was looking for. But wanting to know, O my God, what you would do to the very little one who answered your call, I continued my search and this is what I discovered: *"As one whom a mother caresses, so will I comfort you; you shall be carried at the breasts, and upon the knees they shall caress you."* Ah! never did words more tender and more melodious come to give joy to my soul. The elevator which must raise me to heaven is your arms, O Jesus! And for this I had no need to grow up, but rather I had to remain *little* and become this more and more.

Thérèse wrote this text in June 1897. Its spiritual genesis was in the autumn of 1894, when she recognized the limits of all her efforts to manifest perfect love.

George Desvallières, *Fusion in Jesus Crucified*

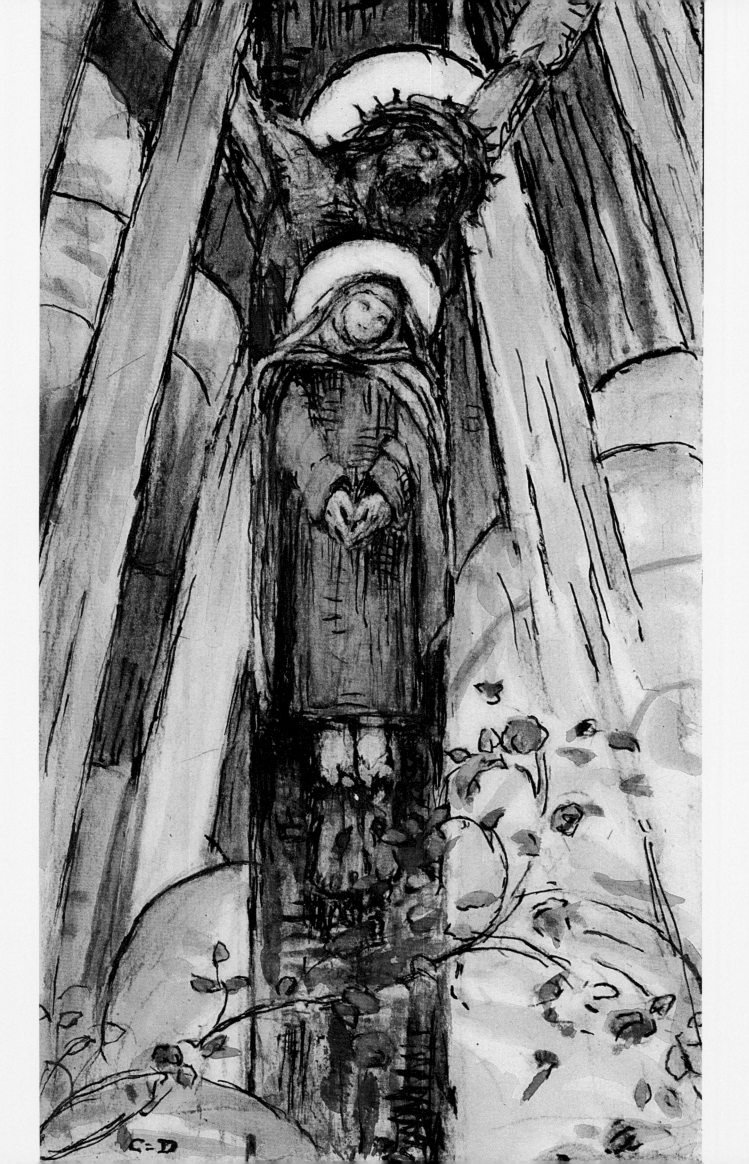

To be little

It is to recognize our nothingness, to expect everything from God as a little child expects everything from its father; it is to be disquieted about nothing, and not to be set on gaining our living.... To be little is not attributing to oneself the virtues that one practices, believing oneself capable of anything, but to recognize that God places this treasure in the hands of his little child to be used when necessary; but it remains always God's treasure. Finally, it is not to become discouraged over one's faults, for children fall often, but they are too little to hurt themselves very much.

Yellow Notebook, August 6, 1897

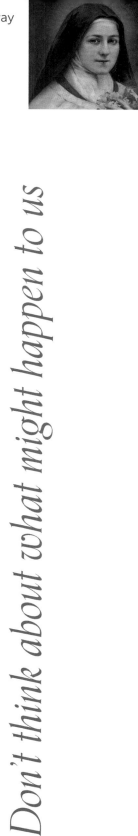

We who run in the way of love shouldn't be thinking of sufferings that can take place in the future; it's a lack of confidence, it's like meddling in the work of creation.

Don't think about what might happen to us

Yellow Notebook, July 23, 1897

Raising oneself to God through trust and love

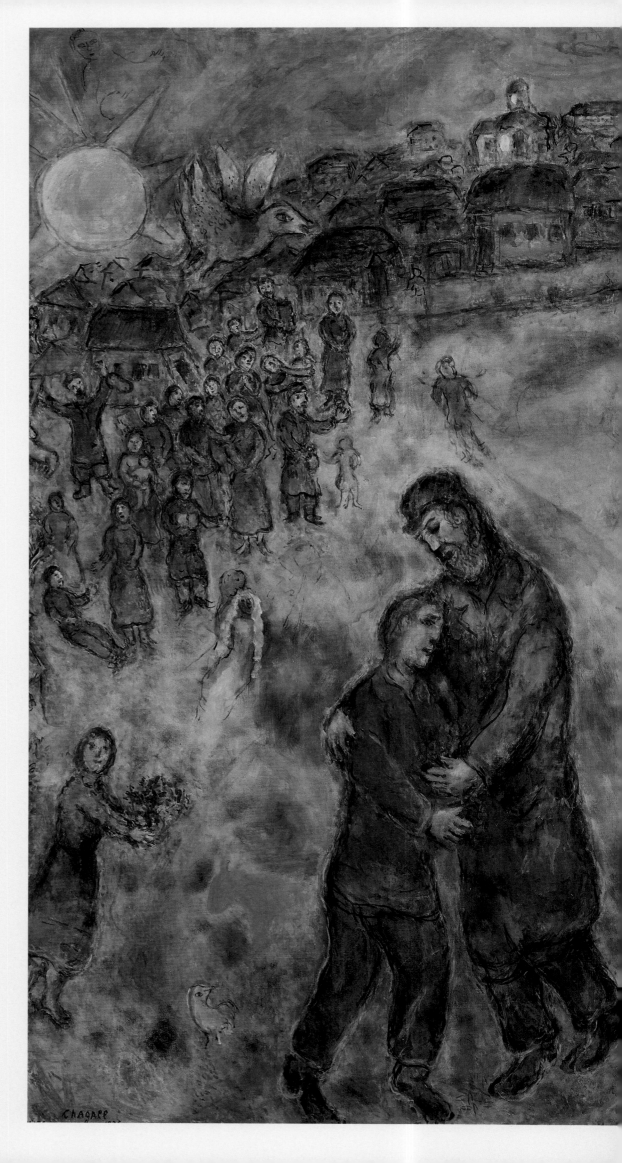

I don't hasten to the first place but to the last; rather than advance like the Pharisee, I repeat, filled with confidence, the publican's humble prayer. Most of all I imitate the conduct of Magdalene; her astonishing or rather her loving audacity which charms the heart of Jesus also attracts my own. Yes, I feel it; even though I had on my conscience all the sins that can be committed, I would go, my heart broken with sorrow, and throw myself into Jesus' arms, for I know how much he loves the prodigal child who returns to him. It is not because God, in his *anticipating* Mercy, has preserved my soul from mortal sin that I go to him with confidence and love.

Marc Chagall,
Prodigal Son

Thérèse compares the sacrifices
or the joys that we offer to a
hair fluttering on our neck that
enslaves or captivates the heart of
Jesus who loves us.

Taking hold of Jesus by the heart

Letter dated July 12, 1896, to Léonie

I assure you that God is much better than you believe. He is content with a glance, a sigh of love.... As for me, I find perfection very easy to practice because I have understood it is a matter of taking hold of Jesus by his heart.... Look at a little child who has just annoyed his mother by flying into a temper or by disobeying her. If he hides away in a corner in a sulky mood and if he cries in fear of being punished, his mamma will not pardon him, certainly, not his fault. But if he comes to her, holding out his little arms, smiling, and saying: "Kiss me, I will not do it again," will his mother be able not to press him to her heart tenderly and forget his childish mischief?... However, she knows her dear little one will do it again on the next occasion, but this does not matter; if he takes her again by her heart, he will not be punished....

It seems to me that if our sacrifices are the hairs which captivate Jesus, our joys are also; for this, it suffices not to center in on a selfish happiness but to offer our Spouse the little joys he is sowing on the path of life to charm our souls and raise them to himself.

L et us line up humbly among the imperfect, let us esteem ourselves as little souls whom God must sustain at each moment. When he sees we are very much convinced of our nothingness, he extends his hand to us. If we still wish to attempt doing something great even under the pretext of zeal, good Jesus leaves us all alone. "But when I said: 'My foot has stumbled,' your mercy, Lord, strengthened me!..." (Psalm 94)." YES, it suffices to humble oneself, to bear with one's imperfections. That is real sanctity! Let us take each other by the hand, dear little sister, and let us run to the last place...no one will come to dispute with us over it....

Bearing sweetly with one's imperfections

Letter dated June 7, 1897, to Sister Geneviève

Thérèse gave up her soul to God on
September 30, 1897. During her last summer,
she wrote another long letter to her novice
mistress, Mother Marie de Gonzague.
She confided to her, "this year, my dear Mother,
the good Lord has given me the grace
to understand what charity is...." And here
she reveals the divine, eternal dimension
of her little way of love.

"It is not those who say: 'Lord, Lord!' who will enter the kingdom of heaven, but those who do the will of my Father in heaven." Jesus has revealed this will several times or I should say on almost every page of his Gospel. But at the Last Supper, when he knew the hearts of his disciples were burning with a more ardent love for him who had just given himself to them in the unspeakable mystery of his Eucharist... he said to them with inexpressible tenderness: "A new commandment I give you, that you love one another: THAT AS I HAVE LOVED YOU, YOU ALSO LOVE ONE ANOTHER. By this will all men know that you are my disciples, if you have love for one another."

When the Lord commanded his people to love their neighbor as themselves, he had not as yet come upon the earth.... But when Jesus gave his apostles a new commandment, HIS OWN COMMANDMENT, as he calls it later on, it is no longer a question of loving one's neighbor as oneself but of loving him *as he, Jesus, has loved him*, and will love him to the consummation of the ages.

Ah! Lord.... It is because you wanted to give me this grace that you made your new commandment. Oh! how I love this new commandment since it gives me the assurance that your will is *to love in me* all those you command me to love!

George Desvallières,
"Your will is to love in me"

How great is the power of *prayer*! One could call it a queen who has at each instant free access to the king and is able to obtain whatever she asks. To be heard it is not necessary to read from a book some beautiful formula composed for the occasion. If this were the case, alas, I would have to be pitied! Outside the *Divine Office*, which I am very unworthy to recite, I do not have the courage to force myself to search out *beautiful* prayers in books. There are so many of them it really gives me a headache! And each prayer is more *beautiful* than the others. I cannot recite them all and not knowing which to choose, I do like children who do not know how to read, I say very simply to God what I wish to say, without composing beautiful sentences, and he always understands me. For me, *prayer* is an aspiration of the heart, it is a simple glance directed to heaven, it is a cry of gratitude and love in the midst of trial as well as joy; finally, it is something great, supernatural, which expands my soul and unites me to Jesus.

George Desvallières, *Mystical Rose*

You did not hesitate, dear Mother, to tell me one day that God was enlightening my soul and that he was giving me even the experience of *years*. O Mother! I am *too little* to have any vanity now, I am *too little* to compose beautiful sentences in order to have you believe that I have a lot of humility. I prefer to agree very simply that the Almighty has done great things in the soul of his divine Mother's child, and the greatest thing is to have shown her her *littleness*, her impotence.

I will come down

Last words to Céline, Septembre 26, 1897

184

"You will look at us from up there in heaven, right?" Céline asked. "No, I shall come down!"

Maurice Denis,
Sister Thérèse of the Child Jesus

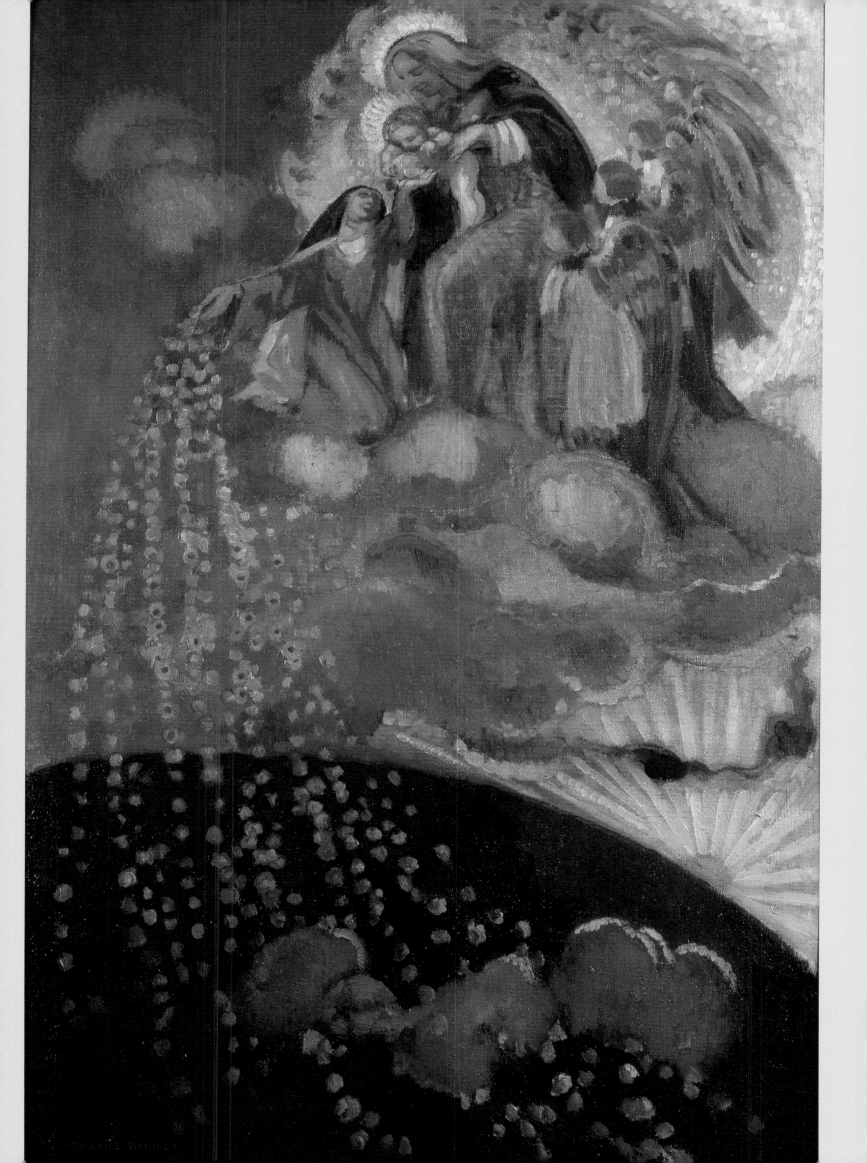

From birth to her mother's death

January 2, 1873: birth of Marie-Françoise Thérèse Martin, in Alençon, rue Saint-Blaise

January 4, 1873: baptism in Notre Dame Church; godmother: her older sister Marie

January 17, 1873: symptoms of enteritis

March 1, 1873: Thérèse is very sick.

Mid-March 1873: Thérèse is sent to be nursed by Rosalie Taillé.

April 2, 1874: Thérèse returns to Alençon for good.

August 28, 1877: death of Zélie Martin

From the move to Lisieux to Mary's smile

August 29, 1877: Zélie's funeral; Pauline chosen as the "second mama"

November 15, 1877: move to Lisieux, to Les Buissonnets

Late 1879 or early 1880: first confession

October 3, 1881: enters the Benedictine Abbey school in Lisieux and has the midday meal there

Summer 1882: Thérèse learns suddenly that Pauline will soon leave for the Carmel and hears her own call.

October 2, 1882: Pauline enters the Carmel and takes the name Sister Agnes of Jesus.

October 1882: Thérèse dreams of taking the name "of the Child Jesus," and this name is indeed proposed to her by Mother Marie de Gonzague.

December 1882: Thérèse suffers from headaches and insomnia.

March 25, 1883, Easter Sunday: start of Thérèse's nervous ailment

April 6, 1883: Thérèse can attend the clothing ceremony of her sister Pauline.

April 7, 1883: relapse into a serious condition; the Martins begin a novena to Our Lady of Victory.

May 13, 1883: Pentecost: the smile of the Virgin cures Thérèse.

From Mary's smile to the grace of Christmas

May 1883: parlor session with the Carmelites that leads to scruples; Thérèse fears that she invented her story of grace.

May 8, 1884: First Communion at the Abbey

May 14, 1884: Confirmation

February 3, 1886: Mother Marie de Gonzague is elected Prioress of the Carmel.

February–March 1886: Thérèse is taken out of the Abbey School permanently because of her health; she is tutored by Madame Papinau.

August 1886: Thérèse learns that Marie will soon leave for the Carmel.

October 7, 1886: Léonie suddenly enters the Poor Clares in Alençon but leaves the community quickly.

October 15, 1886: Marie enters the Carmel with the name Sister Marie of the Sacred Heart.

Late October 1886: Thérèse is freed from her scruples by the intercession of her "little brothers and sisters in heaven."

December 25, 1886: the grace of Christmas; Thérèse regains the spiritual strength that she had lost at age 4.

March 19-20, 1887: Pranzini murders two women and a little girl in Paris.

From the grace of Christmas to her entrance into the Carmel

May 29, 1887, Pentecost: From her father Thérèse receives permission to enter the Carmel at age 15.

July 13, 1887: Pranzini is sentenced to death; Thérèse prays and offers sacrifices for his conversion.

August 1, 1887: Thérèse reads the newspaper account of Pranzini's execution; the criminal asked to kiss a crucifix.

October 8, 1887: Thérèse asks her Uncle Guérin for permission to enter the Carmel at Christmas.

October 22, 1887: under the influence of Mother Agnes, Uncle Guérin consents.

October 25, 1887: Thérèse learns that the superior of the Carmel, Canon Delatroëtte, is opposed to her entrance at such a young age.

October 31, 1887: Thérèse and Louis Martin visit Bishop Hugonin in Bayeux.

November 4, 1887: departure for Rome with the pilgrimage from the Diocese of Coutances

November 14, 1887: visit to the Coliseum

November 20, 1887: Audience with Leo XIII; the pope leaves to the superiors the decision about Thérèse's entrance into the Carmel.

December 28, 1887: letter from Bishop Hugonin to Mother Marie de Gonzague: Thérèse can enter the Carmel.

January 1, 1888: Thérèsee receives her response but she must wait until after Lent to enter the Carmel.

April 9, 1888, Annunciation: Thérèse enters the Carmel.

From the postulancy, to the day of clothing and receiving the veil

From April 9, 1888, to January 10, 1889: Thérèse's postulancy

June 23, 1888: Louis Martin runs away.

June 26, 1888: fire at the house next door to Les Buissonnets

June 27, 1888: Louis Martin is found in Le Havre by Uncle Guérin and Céline.

Early July 1888: Céline and Louis stay in Auteuil.

August 12, 1888: Louis Martin's mental health again deteriorates.

Late October 1888: The Chapter decides that Thérèse may take the habit.

November 1888: because of Monsieur Martin's condition, the clothing ceremony is postponed.

January 5-10, 1889: Thérèse makes a retreat before taking the habit.

January 10, 1889: clothing ceremony in the presence of Louis on a snowy day; Thérèse adds "of the Holy Face" to her name in religion.

From January 10, 1889, to September 24, 1890: Thérèse's novitiate

V. Thérèse, soldier: the underground passage

February 12, 1889: Louis is hospitalized at the Bon-Sauveur in Caen, where he will stay for three years.

January 1890: Thérèse's profession is postponed.

August 28, 1890: beginning of Thérèse's retreat before profession, complete aridity

September 8, 1890: Thérèse makes her profession.

September 24, 1890: Thérèse takes the black veil.

From the retreat with Father Alexis Prou to the first signs of illness

October 7-15, 1891: retreat preached by Father Alexis Prou, who confirms Thérèse in the Little Way and launches her "in full sail."

December 28, 1891: start of the influenza epidemic. Thérèse is one of the few sisters who are still well; she cares for the community, fearlessly, and can receive Communion every day.

May 10, 1892: Louis Martin is still sick, but Uncle Guérin brings him back to Lisieux.

May 12, 1892: Louis Martin's last visit to the Carmel. His last words: "In heaven."

February 20, 1893: election of Pauline, Mother Agnes of Jesus, as Prioress. Thérèse becomes the assistant of Mother Marie de Gonzague in the novitiate.

June 24, 1893: Léonie returns to the Visitation Convent in Caen.

September 1893: Thérèse can leave the novitiate but remains in it.

Spring 1894: Thérèse suffers from a sore throat.

May 8, 1894: major celebrations in Lisieux in honor of Joan of Arc; Thérèse writes a hymn to promote her canonization.

May 27, 1894: paralysis of Louis Martin, who receives Extreme Unction.

July 1, 1894: a physician is consulted because of Thérèse's chest pains and hoarseness.

July 29, 1894: death of Louis Martin.

VI. The light

September 14, 1894: Céline enters the Carmel.

Autumn 1894: Thérèse finds in Céline's notebooks Scripture passages that are decisive for her little way.

December 1894: Mother Agnes asks Thérèse to write down her childhood memories.

January 1895: beginning of the composition of Manuscript A.

February 26, 1895: Thérèse writes the poem "Living on Love."

June 9, 1895: self-offering to Merciful Love.

October 17, 1895: Mother Agnes entrusts Father Bellière to Thérèse.

March 21, 1896: election of Mother Mary de Gonzague as Prioress. Thérèse is confirmed in her role as mistress of novices.

April 3, 1896: first pulmonary hemorrhage in the night from Holy Thursday to Good Friday.

From the first symptoms to the death of Thérèse

April 5, 1896, Easter: enters into the "thick darkness," the night of faith

May 30, 1896: Mother Marie de Gonzague entrusts another missionary, Father Roulland, to Thérèse.

August 8 and 13, 1896: Thérèse composes Manuscript B, also addressed to Sister Marie of the Sacred Heart.

October 8-15, 1896: retreat preached by Father Madeleine, who suggests that she carry the Creed over her heart. Thérèse writes it with her blood.

April 1897, end of Lent: Thérèse falls seriously ill.

May 1897: Thérèse is relieved of all her tasks and from the duty to pray in choir and, at the end of the month, she is relieved of her care of the novices.

June 3, 1897: Mother Marie de Gonzague asks Thérèse to complete the account of her life: Manuscript C.

June 5, 1897: her illness progresses rapidly; Thérèse is thought to be dying.

June 13, 1897: Thérèse is much better after the community makes a novena to Our Lady of Victory.

VII. Darkness

July 6, 1897: pulmonary hemorrhages resume.

July 8, 1897: Thérèse is suffocating; she is brought to the infirmary.

July 30, 1897: Extreme Unction.

August 23, 1897: the pains are so great that Thérèse understands the temptation of suicide.

September 29, 1897: agony, confession

September 30, 1897: Thérèse dies around 7:20 PM in the presence of the assembled community.

March 7, 1898: Monseigneur Hugonin, Bishop of Bayeux, gives permission to publish *The Story of a Soul*.

Easter 1899: the first edition of two thousand copies of *The Story of a Soul* is sold out; a second is prepared.

1899–1901: first graces and healings obtained through the intercession of Thérèse. Pilgrims come to pray at her tomb.

May 26, 1908: a little blind girl, four years old, Reine Fauquet, is cured at the tomb of Thérèse.

March 17, 1915: opening of the apostolic process in Bayeux

April 29, 1923: Beatification of Thérèse by Pius XI

May 17, 1925: Canonization of Thérèse by Pius XI

December 14, 1927: Thérèse is proclaimed patron of the missions together with Saint Francis Xavier.

January 19, 1940: death of Sister Marie of the Sacred Heart

June 16, 1941: death of Léonie

May 3, 1944: Thérèse is proclaimed secondary patron of France by Pius XII.

July 28, 1951: death of Mother Agnes of Jesus

February 25, 1959: death of Céline

October 19, 1997: Thérèse is proclaimed Doctor of the Church by John Paul II.

VIII. The little way

SOURCES OF THE TEXTS

All the texts are taken from the writings or words of Thérèse, except for the letters of Zélie, page 13.

• *Letter from Zélie to the Guérins*, CF 80, July 21, 1872. © The Fathers and brothers of the Society of St. Paul, PAULS/Alba House, Staten Island, NY. Used with permission. www.stpauls.us

• *Letter from Zélie to Céline*, CF 82, September 9, 1872. © The Fathers and Brothers of the Society of St. Paul, PAULS/Alba House, Staten Island, NY. Used with permission. www.stpauls.us

• *Letter from Zélie to Céline*, CF 85, January 16, 1873. © The Fathers and Brothers of the Society of St. Paul, PAULS/Alba House, Staten Island, NY. Used with permission. www.stpauls.us

For this work, we have preserved the important and unusual use by Saint Thérèse of capital letters, punctuation, and abbreviations.

For ease of reading, the cuts in the texts are not indicated.

This collection of texts by Saint Thérèse draws from several sources. You will thus find excerpts from the following texts:

• The **manuscripts A, B, and C**, usually gathered in the work *Story of a Soul*. We indicate here the excerpt by the number of the sheet and the front or back, as it is referenced on the site of the Carmel of Lisieux.

Manuscripts A, B & C, from *Story of a Soul: The Autobiography* of St. Thérèse of Lisieux, John Clarke, O.C.D., Tr. Copyright © 1976, Washington Province of Discalced Carmelites Friars, Inc., ICS Publications. Used with permission. www.icspublications.org

• The **letters** of Saint Thérèse, whose reference begins with LT; From *Saint Thérèse of Lisieux: General Correspondence*, John Clarke, O.C.D., Tr. Copyright © Washington Province of Discalced Carmelites Friars, Inc., ICS Publications. Used with permission. www.icspublications.org

• **Poems and prayers** of Saint Thérèse, whose references begin respectively with PN and Pri;

PN 5, stanzas 1-4, 6, June 1, 1894. Copyright © Washington Province of Discalced Carmelite Friars, Inc. All rights reserved. www.archives-carmel-lisieux.fr

PN 11, *For the Clothing of Marie-Agnes of the Holy Face*, December 18, 1894. Copyright © Washington Province of Discalced Carmelite Friars, Inc. All rights reserved. www.archives-carmel-lisieux.fr

PN 17, *Living on Love!*, stanzas 1 and 5, Tuesday, February 26, 1895, Mardi Gras, Letter to Louise Magdeleine. Copyright © Washington Province of Discalced Carmelite Friars, Inc. All rights reserved. www.archives-carmel-lisieux.fr

PN 18, *The Canticle of Céline*, April 28, 1895, from *Collected Poems of St. Thérèse of Lisieux*, translated by Alan Bancroft. Copyright © 1996, 2001, Gracewing, Herefordshire HR6 0QF. Used with permission.

PN 20, *My Heaven on Earth*, stanzas 3 and 5, August 12, 1895. Copyright © Washington Province of Discalced Carmelite Friars, Inc. All rights reserved. www.archives-carmel-lisieux.fr

PN 25, *My Desires Near Jesus Hidden in His Prison of Love*, Autumn 1895. Copyright © Washington Province of Discalced Carmelite Friars, Inc. All rights reserved. www.archives-carmel-lisieux.fr

PN 34, *Strewing Flowers*, June 28, 1896. Copyright © Washington Province of Discalced Carmelite Friars, Inc. All rights reserved. www.archives-carmel-lisieux.fr

PN 44, *To My Little Brothers in Heaven*, December 28, 1896, stanzas 1, 2, and 9. Copyright © Washington Province of Discalced Carmelite Friars, Inc. All rights reserved. www.archives-carmel-lisieux.fr

PN 45, *My Joy!*, January 21, 1897, stanzas 3 and 4. Copyright © Washington Province of Discalced Carmelite Friars, Inc. All rights reserved. www.archives-carmel-lisieux.fr

PN 46, *To My Guardian Angel*, January 1897, Copyright © Washington Province of Discalced Carmelite Friars, Inc. All rights reserved. www.archives-carmel-lisieux.fr

PN 53, *For Sister Marie of the Trinity*, May 1897. Copyright © Washington Province of Discalced Carmelite Friars, Inc. All rights reserved. All rights reserved. www.archives-carmel-lisieux.fr

PN 54, *Why I Love You, O Mary*, stanzas 22 and 25, May 1897. Copyright © Washington Province of Discalced Carmelite Friars, Inc. All rights reserved. www.archives-carmel-lisieux.fr

Prayer 6, "Act of Oblation to Merciful Love," reprinted in *Story of a Soul: The Autobiography of St. Thérèse of Lisieux*, John Clarke, O.C.D., Tr. Copyright © 1976, Washington Province of Discalced Carmelites Friars, Inc., ICS Publications. Used with permission. www.icspublications.org

• excerpts from the **Yellow Notebook** of Mother Agnes.

From the Yellow Notebook, July 1897. Copyright © Washington Province of Discalced Carmelites Friars, Inc. All rights reserved. www.archives-carmel-lisieux.fr

George Desvallières,
Louis and Zélie Martin surrounded by their guardian angels.

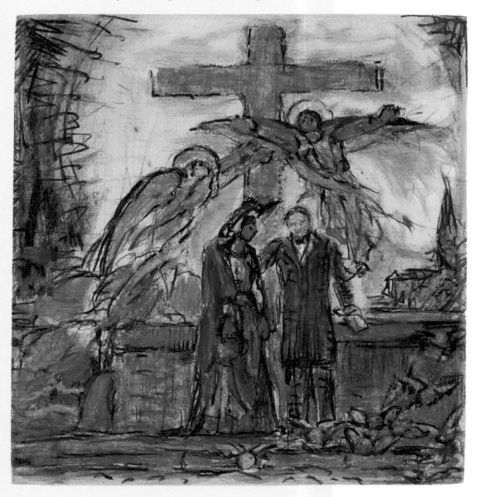

Cover: **George Desvallières** (1861–1950), *Vers le Ciel* (1939), gouache, ink on paper, 8.7 x 7.7 in., Rolin Museum, Autun, France. © Musée Rolin, Autun.

Cover sheet: **Maurice Denis** (1870–1943), *Les Fillettes* (1893, Wallpaper project), gouache, cardboard, Maurice Denis Museum, Saint-Germain-en-Laye, France. © RMN-GP / Benoît Touchard.

Title page: **George Desvallières** (1861–1950), *Croix*, colored offprint of the intaglio engraving made for Louis Chaigne's book Thérèse Martin (1948).

Page 6: **George Desvallières** (1861-1950), *Pluie de roses*, colored offprint of the intaglio engraving made for Louis Chaigne's book Thérèse Martin (1948).

Page 9: **Maurice Denis** (1870-1943), *Sainte Thérèse de l'Enfant-Jésus montant au Ciel* (1939), oil on cardboard, 9.5 x 6.5 in., Rolin Museum, Autun, France. © Musée Rolin, Autun.

Pages 10-11: **John Henry Twachtman** (1853-1902), *On the Terrace* (c. 1890–1900), oil on canvas, 25.2 x 30.1 in., Smithsonian American Art Museum, Washington, D.C.. © Bridgeman Images.

Page 12: **Berthe Morisot** (1841-1895), *Le Berceau* (1872), oil on canvas, 22 x 18.1 in., Orsay Museum, Paris. © Bridgeman Images.

Page 15: **Maurice Denis** (1870-1943), *L'Enfant dans la porte* (1897), oil on cardboard, 10.2 x 7.8 in., Private Collection. © Bridgeman Images.

Page 16: **Maurice Denis** (1870-1943), *La Couronne* (v. 1905), oil on paper mounted on cardboard, 13.8 x 10.2 in., Bayerische Staatsgemäldesammlungen, Neue Pinakothek, Munich, Germany. © BPK, Berlin, Dist. RMN-GP / image BStGS.

Page 18: **Pierre-Auguste Renoir** (1841-1919), *Coco au milieu des roses* (study), oil on canvas, 11.5 x 7.2 in., private collection. © Christie's / Artothek / La Collection.

Page 20: **Pierre-Auguste Renoir** (1841-1919), *Tête de fillette* (c. 1893), oil on canvas, 16.5 x 12.8 in., Private Collection. © Christie's / Artothek / La Collection.

Page 21: **George Desvallières** (1861-1950), *"Je choisis tout"*, colored affprint of the intaglio engraving made for Louis Chaigne's book, *Thérèse Martin* (1948).

Page 23: **Bertha Wegmann** (1847-1926), *Picking Flowers*, oil on canvas, 14.7 x 8.3 in., Private Collection. © Christie's / Artothek / La Collection.

Page 24: **George Desvallières** (1861-1950), *Alençon*, colored offprint of the intaglio engraving made for Louis Chaigne's book *Thérèse Martin* (1948).

Page 25: **Harold Gilman** (1876-1919), *Interior* (1907), oil on canvas, 16.3 x 12.6 in., Southampton City Art Gallery, UK. © Southampton City Art Gallery / Bridgeman Images.

Page 27: **Giuseppe Magni** (1869-1956), *Adoration*, oil on canvas, 27.8 x 34.7 in, private collection. © Christie's / Bridgeman Images / All rights reserved.

Pages 28-29: **Walter Firle** (1859-1929), *A Good Book*, oil on canvas, 18.5 x 26.4 in., private collection. © Christie's / Bridgeman Images.

Pages 30-31: **Berthe Morisot** (1841-1895), *Julie et Eugène Manet* (1883), oil on canvas, 23.6 x 28.7 in., private collection. © Bridgeman Images.

Page 34: **Roberto Ferruzzi** (1853-1934), *Praying Little Girl*, oil on canvas, Museum of Fine Arts, Sevastopol, Ukraine. © Artothek / La Collection.

Pages 36-37: **George Clausen** (1852-1944), *Two Girls Arranging Roses* (1899), oil on canvas, 24 x 30 in., private collection. © The Fine Art Society, London, UK / Bridgeman Images.

Page 39: **Maurice Denis** (1870-1943), *La Communion de Jeanne d'Arc* (1909), oil on canvas, 40.3 x 43.7 in., Museum of Fine Arts, Lyon, France. © MBA, Lyon, Dist. RMN-GP / René-Gabriel Ojeda.

Page 43: **Pierre-Auguste Renoir** (1841-1919), *La Lecture* (v. 1892), oil on canvas, 16.3 x 12.6 in., The Barnes Foundation, Philadelphia. © Barnes Foundation / Bridgeman Images.

Page 44: **Odilon Redon** (1840-1916), *Vierge* (1916), oil on canvas, 19.8 x 27.3 in., Museum of Fine Arts, Bordeaux, France. © Mairie de Bordeaux, musée des Beaux-Arts, photo L. Gauthier.

Page 46: **Amédée Buffet** (1869-1934), *Thérèse et la Vierge au Sourire*, oil on canvas, 63.8 x 21.6 in., Saint-Joseph-des-Carmes Church, chapel Saint-Therese, Paris, France. © Ville de Paris, COARC / Jean-Marc Moser.

Page 49: **George Clausen** (1852-1944), *The Daisy Wreath* (1890), oil on wood, 9.2 x 6.7 in., Private Collection. © The Fine Art Society, London, UK / Bridgeman Images.

Page 51: **George Desvallières** (1861–1950), *« Plus qu'un baiser, une fusion »*, colored offprint of the intaglio engraving made for Louis Chaigne's book *Thérèse Martin* (1948).

Page 52: **Maurice Denis** (1870-1943), *Première communion de sainte Thérèse de Lisieux* (1937), oil on canvas, 68.1 x 53.1 in., Notre-Dame Church, Verneuil-sur-Avre, France. © Catalogue raisonné Maurice Denis.

Page 55: **Maurice Dhomme** (1882–1975), *Tabernacle of the High Altar* (c. 1919), glazed terracotta, Saint-Louis Church, Vincennes, France. © Clément Guillaume / La Collection / All rights reserved.

Page 56: **Maurice Dhomme** (1882–1975), *The Chair* (c. 1919, detail), glazed terracotta, Saint-Louis Church, Vincennes, France. © Clément Guillaume / La Collection / All rights reserved.

Page 58: **Jean-Jacques Henner** (1829–1905), *Madeleine pleurant* (1885), oil on canvas, 10.6 x 6.7 in., Jean-Jacques Henner Museum, Paris, France. © RMN-GP / Franck Raux.

Page 62: **Maurice Denis** (1870–1943), *Le Paradis* (1912), oil on cardboard, 19.7 x 29.5 in., Orsay Museum, Paris. © RMN-GP / Hervé Lewandowski.

Page 65: **Maurice Denis** (1870–1943), *La Nativité à Fourqueux* (detail, c. 1895), oil on canvas, 37.4 x 35 in., Augustins Museum, Toulouse, France. © Photo Josse / La Collection.

Page 67: **George Desvallières** (1861–1950), *L'Enfant Jésus*, colored offprint of the intaglio engraving made for Louis Chaigne's book *Thérèse Martin* (1948).

Pages 70-71: **Marc Chagall** (1887–1985), *Le Cantique des Cantiques IV* (1958), oil on paper, 56.9 x 82.9 in., Marc Chagall National Museum, Nice, France. © RMN-GP (musée Marc Chagall) / Adrien Didierjean. © Adagp, Paris 2022.

Pages 72-73: **Claude Monet** (1840–1926), *La Gare Saint-Lazare : Arrivée d'un train* (1877), oil on canvas, 32.7 x 39.9 in., Fogg Museum, Harvard Art Museums, Cambridge, MA. © Bridgeman Images.

Pages 74-75: **Eugène Carrière** (1849–1906), *Alphonse Daudet et sa fille Edmée* (c. 1891), oil on canvas, 35.4 x 46 in., Orsay Museum, Paris, France. © RMN-GP / Hervé Lewandowski.

Page 79: **Maurice Denis** (1870–1943), *Saint-Pierre de Rome, soir du Vendredi saint* (1928), oil on canvas mounted on cardboard, 15.7 x 11.8 in., private collection. © Catalogue raisonné Maurice Denis, photo Laurent Sully-Jaulmes.

Pages 80-81: **Maurice Denis** (1870–1943), *Le Colisée* (c. 1898), oil on cardboard, 8 x 13.2 in., private collection. © Bridgeman Images.

Page 84: **Paul Cézanne** (1839–1906), *Nature morte au crâne* (1890-1893), oil on canvas, 21.4 x 25.7 in., The Barnes Foundation, Philadelphia, PE. © Barnes Foundation / Bridgeman Images.

Page 87: **George Desvallières** (1861–1950), *Sainte Thérèse et son père* (1938), gouache, ink on paper, 7 x 4.6 in., Rolin Museum, Autun, France. © Musée Rolin, Autun.

Pages 88-89: **Joseph Mallord William Turner** (1775–1851), *The Angel Standing in the Sun* (c. 1846), oil on canvas, 31 x 31 in., Tate Collection, London. © Tate, London, Dist. RMN-GP / Tate Photography.